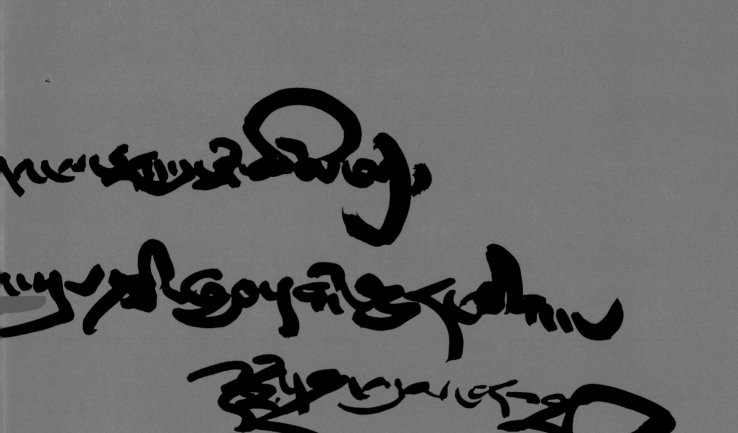

The Art of Calligraphy

· 25ᵀᴴ ·
SHAMBHALA ANNIVERSARY
· 1969-1994 ·

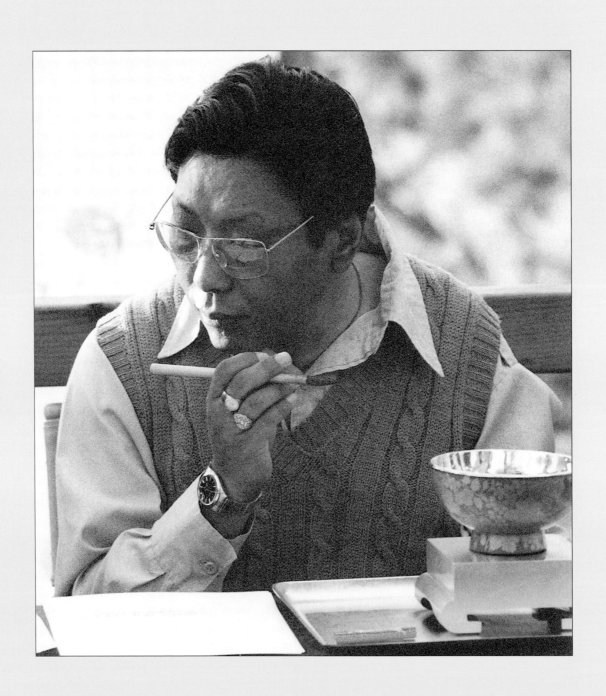

The Art of Calligraphy

JOINING

HEAVEN

& EARTH

Chögyam Trungpa

EDITED BY JUDITH L. LIEF

 SHAMBHALA · *Boston & London* · 1994

Shambhala Publications, Inc.
Horticultural Hall
300 Massachusetts Avenue
Boston, Massachusetts 02115

9 8 7 6 5 4 3 2 1

First Edition

Printed in Singapore on acid-free paper ∞

Distributed in the United States by Random House, Inc., and
in Canada by Random House of Canada Ltd

Library of Congress Cataloging-in-Publication Data

Trungpa, Chogyam, 1939–
 The art of calligraphy: joining heaven and earth / Chögyam
Trungpa; edited by Judith L. Lief. — 1st ed.
 p. cm.
 ISBN 0-87773-591-3
 1. Trungpa, Chogyam, 1939– —Philosophy. 2. Calligraphy,
Tibetan. I. Lief, Judith L. II. Title.
NK3639.T535T782 1994
745.6'199541'092—dc20 94–6361
 CIP

Contents

Acknowledgments

Many people helped in the production of this book. Jane Hester spent countless hours gathering and compiling an inventory of slides of Chögyam Trungpa's calligraphies and then kept track of them as they were reviewed again and again in the difficult process of choosing those to include here. Marlow Root and Beverley Webster helped in the initial stages of gathering slides of the calligraphies from all over the world.

Vajradhatu Archives, Vajradhatu Recordings, and Vajradhatu Publications preserved the tapes and transcripts that served as the basis for the accompanying essay and made these materials available for the use of the editor.

The review committee—Hazel Bercholz, Samuel Bercholz, Carolyn Rose Gimian, Jane Hester, Judith Lief, David Rome, and Emily Hilburn Sell—met many times in order to choose the calligraphies for the book from about two hundred slides.

The Nālandā Translation Committee, particularly Larry Mermelstein, painstakingly reviewed the Tibetan and Sanskrit words in the calligraphies and provided translations. Rebecca Bernen Nowakowski helped review the Chinese.

Several photographers worked to document the calligraphies, including Diana Church, Christine Guest, Dean Janoff, Andrea Roth, and Amaranth Photography Studio.

Helen Berliner, Emily Bower, Dominique Le Grand, Lydia Leavitt, Phyllis Segura, and Sarah Whitehorn all served as regional liaisons between the calligraphy owners and the photographers, which was a complicated process.

The calligraphies had to be carefully prepared for the photographers, which sometimes meant unframing and reframing them. Phil Secord of the Hall of Frame exhibited a great deal of technical skill in this area and also contributed part of his shop to be used for photographing the Halifax calligraphies.

Ann Shaftel offered invaluable technical advice.

The calligraphy owners were generous in letting photographers come into their homes and photograph the calligraphies for the initial inventory and later to remove and photograph those calligraphies chosen for this book.

Thanks to Hazel Bercholz and Emily Hilburn Sell of Shambhala Publications for their insight, good judgment, and exertion.

Throughout this project, Diana J. Mukpo has patiently offered her encouragement, cooperation, and support, without which this book would never have been possible.

The Art of Calligraphy

Introduction

by David I. Rome

Venerating the past in itself will not solve the world's problems. We need to find the link between our traditions and our present experience of life. Nowness, or the magic of the present moment, is what joins the wisdom of the past with the present. When you appreciate a painting or a piece of music or a work of literature, no matter when it was created, you appreciate it now. *You experience the same now in which it was created. It is always* now.*—*Chögyam Trungpa

During the twenty-year period of his remarkable proclamation of Buddhist and Shambhala teachings in the West, brush calligraphy was a primary means of expression for Chögyam Trungpa, Rinpoche. Through his practice of calligraphy, Trungpa Rinpoche captured the moment of *now* and gave it concrete expression in order that others, in other times and places, might also experience *now*.

Trungpa Rinpoche emphasized what he called "art in everyday life." As he explains at some length in the essay published in this book, this means that the attitude, insight, and skill one brings to creating a work of art are not different from the attitude, insight, and skill with which one approaches every aspect of life. The "sacred world" expressed through art is not in opposition to a profane world. Samsara and nirvana are nondual. This basic view, so different in its thrust from the mainstream of Western spiritual and artistic tradition, sees "Art" as part of a continuous spectrum that includes every kind of creativity in one's life—even, as Rinpoche was fond of saying, how we brush our teeth and wear our clothes.

While not separate from everyday life, art nonetheless represents a heightening of experience, what Trungpa Rinpoche refers to as "extending the mind through the sense perceptions." It is the apprehension and the expression of what he calls "basic beauty," beauty that transcends the dualities of beautiful versus ugly. Basic beauty is recognized and captured through the threefold dynamic of heaven, earth, and man. This ancient Oriental hierarchy of the cosmos, and of our experience of

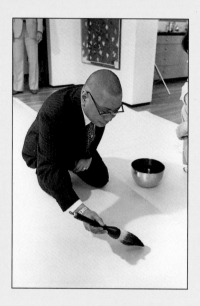

it, forms the basis of Trungpa Rinpoche's essay. Focusing in turn on artistic creation, the process of perception, and the discipline of art-making, he explicates the heaven, earth, and man aspects of each.

The essential moment in both creation and perception, the moment when heaven and earth touch, is indicated by Trungpa Rinpoche's hallmark phrase "first thought best thought." Whether applied to art or to life in general, the import of this slogan is not so much that we should seize on the first thought or image that pops into our head; rather, it is to trust in a state of mind that is uncensored and unmanipulated. "It's the vajrayana [tantric Buddhist] idea of . . . simplicity, no ego involved, just purely"—here Rinpoche pauses and gasps, then continues—"precise! Tchoo!"

The mark of first thought is what Trungpa Rinpoche calls "first dot." In executing a calligraphy, this is literally the first touch of the brush tip, soaked with rich, wet, black ink, to the pure white ground of the paper. It is the moment of joining heaven and earth, making the non-dimensional mark that signals the unconditional nature of space. Figure and ground, form and emptiness, time and space, are born together. From this seed, in turn, all manifest forms and experiential phenomena arise.

Every calligraphy begins with a first dot. From it, the rest of the statement unfolds in the manner of a haiku poem—beginning, middle, end. Indeed, Trungpa Rinpoche's calligraphies can be read as visual haiku, a kind of nonthought action painting that captures and records unique moments of awareness. They are—to borrow Rinpoche's characterization of the nature of reality as perceived by the fully realized mind of mahamudra—"symbols of themselves."

Only a small number of Trungpa Rinpoche's calligraphies have been reproduced heretofore, some in very limited editions. The great majority exist only as originals, and most of these are in private hands. Since Rinpoche's death in April 1987, a major archival effort has been launched to gather together and document his work in its multitude of forms, including a sustained effort to photograph and document the calligraphies. It is now possible to offer a representative selection of the hundreds of black-on-white calligraphies executed by Trungpa Rinpoche from the time of his arrival in North America in 1970. We are pleased to present these to a broader public in the form of this book, and we feel confident that Rinpoche himself would have been delighted by such a production. His essay published here under the title "Heaven,

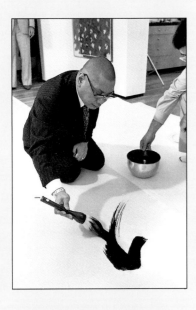

Earth, and Man" has been freshly edited from a series of talks given in July 1979 in Boulder, Colorado. In addition to enriching one's appreciation for the works here illustrated, it serves as an important statement in its own right of Trungpa Rinpoche's view and practice of art.

Although a full biographical sketch is beyond the scope of this introduction, some understanding of Trungpa Rinpoche's life journey as it pertains to the development of his calligraphy practice may be helpful. Vidyadhara the Venerable Chögyam Trungpa, Rinpoche, Lord Mukpo, was born into a seminomadic peasant family in a remote region of Eastern Tibet in or about 1940. At the age of one year he was recognized as the eleventh *tülku* (reborn teacher) in the lineage of Trung Mase, a great Tibetan Buddhist master of the fifteenth century. He was brought to the monastery of Surmang, ancient seat of the Trungpa line, and began the rigorous monastic training that would prepare him to assume its leadership. Though no one could have imagined it then, this training also laid the foundation for his remarkable career as a Buddhist teacher in the West from the mid-1960s on.

In his autobiography, *Born in Tibet*, Trungpa Rinpoche mentions Tibetan calligraphy as an important component in his training from an early age. Responding to a question during the 1979 "Dharma Art" seminar, he gives the following account: "When calligraphy is taught in Tibet, China or Japan, at first you don't do your calligraphy fast at all. The 'grass' style, or cursive style, is not taught right away. You are trained first in the very classical style of how to make a stroke, how to dip your brush, how to use the nib in your inkpot. Everything is precise, very precise. In fact, at the beginning you just learn to make straight lines on your paper, which is quite boring from the American point of view. But one has to go through those processes. You cannot become a full-fledged so-called artist on the basis of frivolity and quick jumps. There is no such thing as a crash-course Berlitz school of art. That's a contradiction in terms."

After mastering straight lines, Rinpoche would have been set to work on learning the several varieties of the formal cursive script called *u-me*. At some point he would have also practiced *u-chen*, the block-letter alphabet adapted from an Indian script in the seventh century—the same letters that are painstakingly carved in reverse on woodblocks in the traditional technique for printing sacred texts. Finally, he developed his own distinctive style of the fluid cursive script known as *chu-yik*.

Examples of all three calligraphic hands appear in this book. In some cases (see, for example, page 111), block letters are employed for a main text consisting of a single word or seed syllable, upon which a longer passage written in cursive expands or comments.

Growing up in Eastern Tibet, Trungpa Rinpoche would have had considerable exposure to aspects of Chinese and Mongolian culture. Though he does not mention it specifically, one may guess that he would have seen Chinese calligraphy in some form from an early age (including the missives of a rapidly encroaching Chinese Communist regime). His initial exposure to Japanese culture, which would play so large a role in his work both as meditation teacher and artist, seems to have occurred during the three years he spent in India following his escape from Tibet in 1959. From India he went to England and Oxford University, and it was during this period that he undertook a concentrated study of ikebana, Japanese flower arrangement, under Stella Coe, a prominent British teacher in the Sogetsu line. Here Trungpa Rinpoche would have worked hands-on with the organizing principles of heaven, earth, and man that form the subject of his essay in this book.

Shortly after arriving in North America in 1970, Trungpa Rinpoche had two auspicious meetings in California with Shunryu Suzuki Roshi, founder of San Francisco Zen Center and a key figure in the establishment of genuine Zen practice in the West. A powerful rapport arose between the two teachers, the younger at the outset of his career and the older, as it turned out, nearing the close of his. Trungpa Rinpoche was excited by the elegance and simplicity of the Zen aesthetic. Henceforth it became a key to many aspects of his re-visioning of Tibetan Buddhist tradition for the West. His dialogue with Zen, including Zen calligraphy practice, continued in succeeding years with other prominent Japanese teachers in the West, such as Taizan Maezumi Roshi and Kobun Chino Roshi.

The Japanese current in Trungpa Rinpoche's work culminated in the arrival, in 1980, of Kanjuro Shibata Sensei. Twentieth-generation bowmaker to the Japanese emperor and master of *kyudo,* the ancient art of Japanese archery, Shibata Sensei came to America at Trungpa Rinpoche's invitation to train his students in *kyudo* and, in a larger sense, in the court and warrior traditions of feudal Japan. A close colleagueship, based on mutual respect, developed between the two and further piqued Rinpoche's interest in things Japanese and Chinese. He applied himself to the study of *kanji,* the Chinese ideograms that for thousands of years have been the vehicle of much of the world's greatest calligraphy.

This period also marked the culmination of Trungpa Rinpoche's teachings concerning the Kingdom of Shambhala. He lost no time in putting *kanji* to use in a series of calligraphies expressing key Shambhala ideas: Great Eastern Sun, Emperor, Windhorse, Kami. Often he would painstakingly fashion the formal *kanji* symbol and then fluidly add the identical word in Tibetan. Or, if his friend Shibata Sensei were present, he would request him to execute Japanese calligraphy to mirror his own in Tibetan.

Trungpa Rinpoche delighted in having partners in the creation of art. At times he presented this as a challenge, as when he would start off a spontaneous poem and then—unexpectedly, perhaps—call upon everyone present to contribute a few lines before "capping" the group effort with his own finale. One of the funniest and most captivating examples of such artistic partnering is the joint calligraphy with Karel Appel, the eminent Dutch artist (page 149), done when Appel visited The Naropa Institute in the early eighties.

A large number of Trungpa Rinpoche's calligraphies consist of single words or short phrases, usually central concepts or images of buddhadharma and Shambhala teaching: *chö* (dharma); *prajna* (discriminating awareness); *sopa* (patience); *sharchen nyima* (Great Eastern Sun); *lungta* (windhorse). Sometimes Rinpoche would calligraph a stanza of poetry, the poem generally as spontaneous as the calligraphy itself.

Vowel sounds in Tibetan, not unlike Hebrew, are represented by signs above and below the consonants. This provides a pleasing vertical dimension to the writing that complements the left-to-right axis of the letters. Although Tibetan, like English, is normally written horizontally, Trungpa Rinpoche frequently arranged words and even separate syllables vertically, thus achieving an effect closer to that of Chinese or Japanese calligraphy.

Trungpa Rinpoche's Tibetan calligraphies, executed with Japanese brush and sumi ink, represent a creative merging of two distinct Oriental traditions. The traditional writing implement of Tibet is the bamboo pen. As in Hebrew and Gothic lettering, the pen lends itself to straight lines, sharp angles, and abrupt transitions from thick to thin. The brush employed for Chinese and Japanese calligraphy, on the other hand, is given to sinuous curves and subtle modulations of direction and stroke width. Rinpoche (as in so many matters) got the best of both worlds.

Inevitably, Trungpa Rinpoche also experimented with calligraphy in English (see example on page 147). However, Roman lettering offers much less dynamic scope than the Oriental written symbols, and it is

certainly for this reason rather than any cultural bias that Rinpoche stuck mostly to Tibetan and, later, Chinese and Japanese, in his calligraphy. (By contrast, his mature poetry is almost entirely in English, which offered him a much larger stylistic and imagistic scope than Tibetan.) There are even examples of Hebrew calligraphy by Trungpa Rinpoche; although he did not know the language, he appreciated its calligraphic potential and was delighted to copy from words written out by students of Jewish background.

Another frequent subject of Rinpoche's calligraphies are "seed syllables." In vajrayana Buddhism, certain monosyllabic sounds—OM is the best-known example—serve to embody the essential energy of a tantric deity. Voiced and visualized in meditative practice as a means for rousing the deity's presence, seed syllables also serve in written form to empower places and representations and generally to protect practitioners' state of mind and sacralize their perceptions. The calligraphy HUM BHYO (page 83) combines the seed syllables of male and female protectors. Trungpa Rinpoche executed and presented this calligraphy each time a local dharma study group became a Dharmadhatu, a full-fledged and legal member of Vajradhatu, the international network of Buddhist practice communities that he founded.

There are also abstract calligraphies, dating mostly from the late seventies. They seem to represent a convergence of several artistic disciplines: traditional Oriental calligraphy, Tibetan thangka painting (there are a handful of gemlike traditional thangkas that Rinpoche painted early on), experiments with watercolors, and occasional small drawings, often of a humorous sort. Just as his poetic voice, which at first was imitative of both Tibetan and British traditional modes, released into something much freer and more idiosyncratic after his arrival in North America, so Rinpoche's use of brush and ink became progressively bolder and more original. In the early seventies he experimented with ink washes to create a background or textural space, against which he calligraphed a symbol or an abstract image, often organic in feeling. But the technique he settled on and stayed with was one in which space is articulated simply by the contrast of the white paper and the black gesture that it accommodates.

Trungpa Rinpoche regarded the merchandising of art as corrupting, to both artist and audience. Although in later years he was generous in executing calligraphies for sale at benefit auctions, Rinpoche himself never did artwork for the purpose of generating income. Unlike his

poetic composition, however, which seemed to occur spontaneously, Trungpa Rinpoche's calligraphies were almost always done for some specific purpose. Many were made for the walls of practice centers such as Karmê-Chöling in Vermont, Rocky Mountain Dharma Center in Colorado, or the numerous Dharmadhatus in cities throughout North America and Europe. Others were presented to individuals. In fact, one can often identify the homes of his married students by the framed calligraphy hanging above the living room mantle—a wedding gift from Rinpoche. Or a student setting up in business would request a calligraphy to hang auspiciously in the new office. Some calligraphies were executed publicly in the course of programs on "Visual Dharma" or "Dharma Art," such as the one from which Rinpoche's essay in this book is drawn. In the late seventies and early eighties he did a series of major dharma art "Installations," in which calligraphy appeared as just one element among an entire arrangement of room space, furnishings, art objects, and large flower arrangements.*

Trungpa Rinpoche had a collection of Japanese calligraphy brushes of different sizes. These he regarded as sacred implements, treating them with the care and respect of a warrior for his weapons. If a brush hair came loose, Rinpoche would carefully remove it before proceeding with the execution of a calligraphy. For ink, Rinpoche generally made use of the bottled Japanese sumi ink available in American shops. He almost always worked in black, on rare occasions in red.

Paper type and quality varied enormously. In the earlier years, Rinpoche tended to employ whatever surface was ready to hand (including, at times, the wall). Especially during his frequent travels, the quality of the materials he had to work with was uneven. Some of his largest and most dramatic calligraphies were, unfortunately, done on rolls of cheap newsprint. In later years the importance of high-quality paper was better appreciated, and Rinpoche made use of fine woven and laid papers, including several varieties of Japanese manufacture. He especially favored traditional Japanese shikishi boards, gold-leafed or off-white, and many of his late works were done on them (because of the difficulty of reproducing the gold ground, no examples of this type have been included). He was comfortable working at all scales, from the surface of a folding fan to long rolls laid on the floor, which he worked over Jackson Pollock style.

Rinpoche had a considerable collection of seals, each with its own particular history and significance. Most valuable were the ancient seals of

*One such installation is depicted in the documentary film *Discovering Elegance,* shot in Los Angeles in 1980.

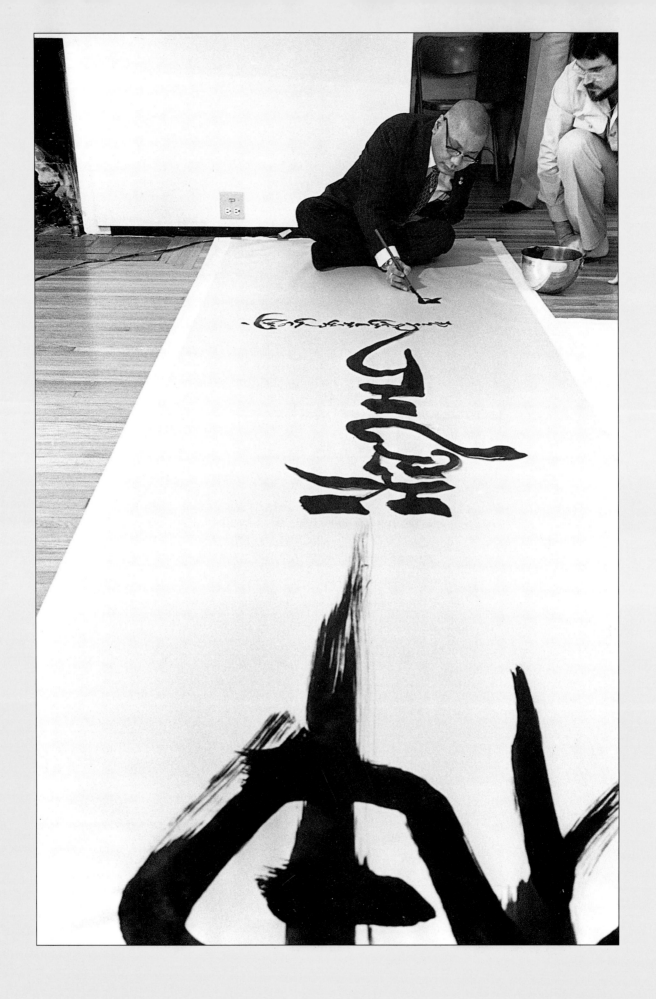

the Trungpa lineage, some of them centuries old. For these, he had a special case prepared with fitted indentations, which was carried during his travels by a trusted aide, like the black box accompanying a President. Woe if it should be misplaced! The simplest of the seals was the Sanskrit *evam*, traditional seal of the Trungpa tülkus, which he eventually passed on to his American regent, Ösel Tendzin (e.g., pages 53 and 87). Larger traditional seals, one of which was a gift from the emperor of China to the fifth Trungpa in the early seventeenth century, are in Tibetan or Chinese seal script. Inevitably, Trungpa Rinpoche added to the collection of seals he had inherited from his predecessors new ones of his own design. Prominent among these are the large and small scorpion seals. The scorpion is a symbol of sovereignty and command— once one has been stung by the scorpion there is no undoing it. Rinpoche used the scorpion seals on calligraphies embodying themes connected with the Kingdom of Shambhala. The new seals were manufactured initially in hard rubber; later, traditional ivory or stone ones were made, and Rinpoche had one scorpion seal produced from meteoric iron. (For additional information about the seals, see Appendix.)

Rinpoche was partially paralyzed on his left side, the result of an automobile accident. It was difficult for him to sit in "warrior posture," or *seiza*, the traditional Japanese kneeling posture for calligraphy. When working on a small sheet, he would sit at his desk. Such was the case when he calligraphed names for the traditional refuge and bodhisattva vow ceremonies; these were done on 8½- by 11-inch specially watermarked bond paper, sometimes over one hundred at a time in rapid succession. On these occasions a small assembly line of assistants would be on hand to help seal, remove for drying, and order the sheets for the ceremony which Rinpoche would perform, later the same day or on the day following. When executing larger calligraphies, Rinpoche stood at a table. This may have been specially set up in the sitting room adjoining his downtown office; in later years, it would more often have been the dining room table at the Kalapa Court, Rinpoche's large residence on "the Hill" in Boulder, Colorado.

When about to execute a calligraphy, Trungpa Rinpoche would seem for a few moments to be in a state of absorption, often accompanied by a gesture of repeated dipping of the brush into the ink and smoothing the brush hairs against the side of the ink bowl. Then he would raise the brush, while gazing intently at the white space of the paper before him. In this second, onlookers could feel an arresting of habitual thought patterns as space and time crystallized into a pure, undivided moment.

Then, gently but with great conviction, the brush would descend to the paper and make its first dot. Often Rinpoche would pause the brush on this first mark, as if waiting for the calligraphy to be born from its seed. Then the brush would start to move, in a continual forward flow free from hesitation or strain.

Typically, the initial one or two strokes of a calligraphy by Trungpa Rinpoche have a gentle deliberateness, evoking a sense of mindfulness and precision; then there is a crescendo, expressed in greater speed of execution and a sense of leap or abrupt sword stroke; finally, a "follow-through" stroke both completes the gesture and lets go of it. This pattern can be seen in many of the works, abstract as well as literal.

After a moment of inspection, Rinpoche would set down his brush and select a seal. Then, as an assistant held firm the container of thick scarlet ink, he would ink the seal and apply it definitively to the paper, pressing hard with a slight rocking motion to ensure a sharp impression. Now the assistants would hold down the paper as Rinpoche pulled the seal off with a pleasing snap. For a brief moment, all would admire the newborn, completed artwork, before carefully removing it to a nearby surface to dry.

With a few exceptions, Trungpa Rinpoche worked in black on white or black on gold. A third focal point of color is provided by the brilliant red of the seal. His use of seals frequently went beyond the simple function of identification, becoming an active element in the composition— multiple impressions, impressions turned at different angles, or masked so that only a portion of the seal appears.

As with his use of seals, Trungpa Rinpoche also signed his work in a variety of ways. His earlier calligraphies are usually signed simply with his own name in Tibetan: *Chökyi Gyatso ne tri* ("written by Chökyi Gyatso"). Meaning "Ocean of Dharma," which in Tibetan often contracts to *Chö-gyam*, this is the "dharma" or religious name that Rinpoche received in childhood after his recognition as the eleventh rebirth in the Trungpa lineage. He rarely uses "Trungpa" to identify himself, and never "Rinpoche," an honorific meaning "Great Jewel" that is used for all tülkus. He at times uses other titles, such as Dorje Dzinpa ("Vajra Holder"), a high distinction bestowed on him by His Holiness Gyalwang Karmapa XVI, head of the Kagyü lineage of Tibetan Buddhism. Later works, representing Shambhalian themes, are often signed with his Shambhala warrior name, Dorje Dradül ("Indestructible Subjugator of Enemies") or Sakyong Dorje Dradül ("The Earth-Protector Indestructible Subjugator"). Sometimes he employed the English initials

"DD of M," standing for Dorje Dradül of Mukpo. Mukpo, his family name, derives from one of the six ancient clans of Tibet. Trungpa Rinpoche traced his ancestry to the most famous Mukpo of all, the legendary warrior-king Gesar of Ling.

Rinpoche frequently equated brush and sword. "The brush is tempered and folded and beaten as a good samurai sword. . . . In conquering from the East, brushstroke is the weapon . . . you realize that brush cuts and sword paints." Trungpa Rinpoche wielded his calligraphy brush as a sacred weapon. For him, the brush was a sword of nonaggression, a proclamation of transcending neurotic attachments and uplifting life for oneself and others. We offer this volume with the hope that it may contribute in some degree to the accomplishment of Rinpoche's dharma warrior-king vision for a world of peace, courage, and beauty.

David I. Rome served as Trungpa Rinpoche's private secretary from 1974 to 1983.

HEAVEN,

EARTH

& MAN

This essay is based on a seminar entitled "Dharma Art" given in Boulder, Colorado, July 13–19, 1979. The seminar included lectures and discussions, group meditation practice, and art and ikebana exhibits. The Vidyadhara, Chögyam Trungpa, Rinpoche, demonstrated his talks with calligraphies and illustrations, created and displayed on the spot by means of an overhead projector. In the discussions following each talk, Trungpa Rinpoche and the seminar participants practiced spontaneous poetry composition, creating a series of three-line poems based on the heaven, earth, and man principle. So in presenting this material, the Vidyadhara made use of the interplay of spontaneous expression, meditation, and study.

Heaven, Earth, and Man

1. Dharma and Art

"Genuine art tells the truth."

People often start with art and discover dharma out of that. But our approach is different: we begin with dharma, and then we try to find if there is any art in it. We start right at the beginning, right at the basic point, with the question of who we are, what we are, and what we are trying to do in terms of art. So in discussing dharma art, it is important to have some familiarity with dharma and why it is art, which is an interesting question.

Some people say that art is a way of expressing themselves which communicates to others. Others say that art is a discovery they have made out of nowhere, and from that they find their way of relating with others. Some people say art is pure spontaneity: if they are spontaneous, that in itself is art. But there are some problems with those basic conceptions of art. We first of all have to look at the intention or the motivation to create art. The motivation may come from a loss of your sense of identity. You have lost connection with the rest of the world and you cannot make friends with anybody. You may be crazy, sick, or confused, but you find one thread of connection, which is your talent, your artwork—so you try to hang on to that. In this case, you try to make a connection with the rest of the world by demonstrating your talent, regarding your art as a saving grace, a life rope. It is your last chance.

Sometimes people become known as great artists because of the quality of their art. People buy their works of art; they don't buy the artist, particularly. They run into the artist's studio and buy his or her production and get out as soon as possible, without getting into the artist's personality. In other cases, people use their works of art as calling cards, the hors d'oeuvre approach. Their artwork expresses their personality, so people begin to like them and accept them because of their art. Their

15

art becomes a way of magnetizing people to themselves. Some artists are hermits who simply enjoy working on their art and are not concerned with selling what is produced. Such artists often refuse to sell or exhibit their work at all. Their only discipline or pleasure is in the creation of the work of art itself. These artists pursue the solitary style of the rhinoceros.

There are hundreds of millions of types of artists and approaches. Some artists are very neurotic; others are not all that neurotic. They are very individualistic, and many artists are garish in propagating their particular ego: their own colors, forms, and sounds. I'm not particularly trying to cut down artists. But we have to recognize how much neurosis comes out in works of art. We could quite safely say that at present sixty percent of the art produced is neurotic. The rest of it may be somewhat decent.

The problem stems from labeling ourselves as artists. When we begin to label ourselves as some kind of artist—"I'm a poet, a musician, painter, weaver, sculptor, potter," what have you—that prevents us from reaching beyond that particular scope. All sorts of neurotic possibilities could come out of that: hanging on to clay in order to produce a pot, hanging on to canvas in order to produce a painting, hanging on to a musical instrument in order to produce a sound. In the theistic world we never see any medium beyond the immediate situation, and that becomes a problem. For instance, when you are born, you immediately try to reach your mother's nipples; you try to do so as fast as you can, so that you don't have to think about your birth anymore. Then somebody else has to get a diaper to catch your cream- or mustard-colored deposit at the other end. We have been acting in that way for a long time, in our physical process of growth as well as when we produce works of art. We hang on to our immediate medium as our confirmation, so there is no space at all for us to expand beyond what is there. That is a problem. On the other hand, it might be a source of possibilities.

The name "artist" is not a trademark. The problem of the twentieth century is that everyone has become merchandised, everybody is a mercenary, everybody has to have a label: either you are a dentist, an artist, a plumber, a dishwasher, or whatever. And the label of "artist" is the biggest problem of all. Even if you regard yourself as an artist, when you fill in the occupation blank, I request you not to write "I am an artist." You might be the greatest artist, but that doesn't mean you have to put "artist" as your occupation. That is absurd! Instead you might write "housewife" or "businesswoman"—that is much better than calling yourself an artist. It seems to be problematic if you declare yourself

an artist, because that means you are limiting yourself purely to art-work in the literal sense, as something very extraordinary and unusual. But from my way of thinking, and from what my training tells me, when you have perfected your art and developed your sensitivities, you cannot call yourself anybody at all!

Dharma means "norm" or "truth." It is also defined as peace and coolness, because it reduces the heat of neurosis, the heat of aggression, passion, and ignorance. So dharma is very ordinary, very simple. It is the stage before you lay your hand on your brush, your clay, your canvas—very basic, peaceful and cool, free from neurosis.

Neurosis is that which creates obstacles to perceiving the phenomenal world properly and fully, as a true artist should. The basic obstacle to clear perception is omnipresent anxiety, which does not allow us to relate to ourselves or to the world outside ourselves. There is constant anxiety, and out of that anxiety comes a feeling of heat. It is like entering a hot room—we feel claustrophobic and there is no fresh air. That claustrophobia leads us to contract our sense perceptions. When there is one hundred percent claustrophobia—the full heat of neurosis—we can't see, we can't smell, we can't taste, we can't hear, we can't feel. Our sense perceptions are numbed, which is a great obstacle to creating a work of art.

Tonight we are talking about art as a basic understanding of dharma. We sometimes have a problem with that basic understanding because we would like to come up with some gimmick. For instance, you might go up in the mountains and catch a baby monkey and bring him home, hoping that little baby monkey can play on your shoulder, run around your courtyard, and play in your kitchen. You hope he will relieve your claustrophobia, the heat of your neurosis. When he first decides to come along with you, that baby monkey might behave himself. But over time he begins to become an extension of your neurosis, because the power of your neurosis is so strong and effective. So the monkey begins to become an expression of your neurosis, in the same way as your artwork does.

Some people say that if there were no neurosis, they could not become good artists. This view of art is the opposite of a sense of peace and coolness. It undermines the possibility of intrinsic beauty. Fundamentally, art is the expression of unconditional beauty, which transcends the ordinary beauty of good and bad. From that unconditional beauty, which is peaceful and cool, arises the possibility of being able to relax, and thereby to perceive the phenomenal world and one's own senses properly. It is not a question of talent. Everybody has the tendency toward intrinsic beauty and intrinsic goodness, and talent comes along with

that automatically. When your visual and auditory world is properly synchronized and you have a sense of humor, you are able to perceive the phenomenal world fully and truly. That is talent. Talent comes from the appreciation of basic beauty and basic goodness arising from the fundamental peace and coolness of dharma.

When we begin to perceive the phenomenal world with that sense of basic goodness, peace, and beauty, conflict begins to subside and we start to perceive our world clearly and thoroughly. There are no questions, no obstacles. As anxiety subsides, sense perceptions become workable because they are no longer distorted by any neurosis. With that understanding, meditation practice becomes very powerful. Through the practice of meditation, we can relate with our thoughts, our mind, and our breath, and begin to discover the clarity of our sense perceptions and our thinking process. The ground of the true artist includes peace and coolness, as well as unconditional beauty. It is free from neurosis. That ground enables us to become dharmic people.

From that ground, based on the practice of meditation, we could branch out further and experience ourselves as what we are and who we are altogether. Sitting practice is a way of discovering ourselves. This particular approach is not necessarily my own invention. It is compatible with Christianity and other mystical traditions. The Quakers and Shakers developed traditions of suddenly rousing themselves in a particular moment to connect themselves with God. When they are roused, they lose their reference point altogether, they become nontheistic on the spot. Because of that, they are regarded as good Christians! The same thing could apply to Judaism and to the Islamic tradition. [In such mystical traditions] when there is the highest moment of turn-on, your mind is open, on the spot. There is nothing happening, therefore everything happens. In the afterthought we try to resume being ourselves, being such-and-such, which becomes very embarrassing and problematic, like the cat who shits on the ground and covers it up with dirt.

When we begin to realize that the principle of dharma exists within us, the heat of neurosis is cooled and pure insight takes place. Because restfulness exists beyond the neurosis, we begin to feel good about the whole thing. We could safely say that the principle of art is related with that idea of trust and relaxation. Such trust in ourselves comes from realizing that we do not have to sacrifice ourselves to neurosis. And relaxation can happen because such trust has become a part of our existence. Therefore we feel we can afford to open our eyes and all our sense perceptions fully.

When relaxation develops in us, through letting go of neurosis and experiencing some sense of space and cool fresh air around us, we begin to feel good about ourselves. We feel that our existence is worthwhile. In turn we feel that our communication with others could also be worthwhile and pure and good. On the whole we begin to feel that we are not cheating anybody; we are not making anything up on the spot. We begin to feel that we are fully genuine. From that point of view, one of the basic principles of a work of art is the absence of lying. Genuine art tells the truth.

In this regard, poetic license is dubious. Stretching your logic to the extreme and supporting others or yourself through indulgence of any kind, or because you are good and popular and technically right, does not apply to dharma art at all. Everything has to be done with genuineness, as it actually is, in the name of basic beauty and basic goodness. Whenever no basic goodness or basic beauty is expressed, what you do is neurotic and destructive. You must not destroy people with your art through poetic license.

Some artists feel they have the right to create neurosis in their artwork in the name of art. Lots of people have done just that, and they have succeeded because when you attach yourself to other people's neurosis, you are bound to be successful. Cultivating other people's sanity is obviously more difficult. Nonetheless, you cannot jump the gun and latch onto the easy way out for the sake of making lots of money or becoming a big name. There has to be the basic integrity of maintaining our human society in a state of sanity. That is and should be the only way to work with art. The purpose of a work of art is bodhisattva action. This means that your production, manifestation, demonstration, and performance should be geared toward waking people up from their neurosis.

Being an "artist" is not an occupation, it is your life, your whole being. From the time you wake up in the morning, when the buzzer in your clock rings to get you up, until you go to bed, every perception you experience is an expression of vision—the light coming through your window, the hot-water kettle boiling to make tea, the sizzling of the bacon on the stove, the way your children get up with a yawn and your wife comes down in her dressing gown into the kitchen. If you limit that by saying "I am an artist," that is terrible. It is showing disrespect for your discipline. We could safely say that there is no such thing as an artist, or art-ism, at all. There is just art—dharma art, hopefully.

My first important project here is to let everybody know that dharma art means not creating further pollution in society; dharma art means

creating greater vision and greater sanity. This is a very important point. I would like to repeat it again and again and again so that we have an idea of what direction we are going in. I am not here to present a Buddhist gimmick, so that you can give your artwork a further twist, saying that you have studied with a Buddhist teacher and taken part in the Buddhist world. Instead, what we are trying to do is to be very genuine and benevolent and basic, so that we do not create passion, aggression, and ignorance in ourselves or in our audience. That is a very important point, and I would be completely appalled if we achieved the opposite result. I would commit *seppuku* on the spot.

2. Creation

"Being an artist is not an occupation;
it is your life, your whole being."

The principle of heaven, earth, and man seems to be basic to a work of art. Although this principle has the ring of visual art, it also could be applied to auditory art such as poetry or music, as well as to physical or three-dimensional art. The principle of heaven, earth, and man applies to calligraphy, painting, interior decoration, building a city, creating heaven and earth, designing an airplane or an ocean liner, organizing the dishwashing by choosing which dish to wash first, or vacuuming the floor. All of those works of art are included completely in the principle of heaven, earth, and man.

The heaven, earth, and man principle comes from the Chinese tradition, and it was developed further in Japan. Currently the phrase "heaven, earth, and man" is very much connected with the tradition of ikebana, or Japanese flower arranging, but we should not restrict it to that. If you study the architectural vision of a place such as Nalanda University in India, or if you visit Bodhgaya, with its stupa and its compound, or the Buddhist and Hindu temple structures of Indonesia, you see that they are all founded on the heaven, earth, and man principle. This principle is also seen in the interior decor of temples built in medieval times and occupied by a group of practitioners: monks, deities,

lay students, and their teacher. The principle of heaven, earth, and man is also reflected in the makeup of the imperial courts of China, Japan, and Korea, and in their official hierarchy, which included an emperor, empress, ministers, subjects, and so forth. In horseback riding, the rider, the horse, and his performance are connected with the heaven, earth, and man principle, which also applies to archery and swordsmanship. Anything we do, traditionally speaking, whether it is Occidental or Oriental, contains the basic principle of heaven, earth, and man. At this point we are talking about the heaven, earth, and man principle from the artist's point of view rather than the audience's.

In the concept of heaven, earth, and man, the first aspect is heaven. The heaven principle is connected with nonthought, or vision. The idea of heaven is like being provided with a big canvas, with all the oil paints, and a good brush. You have an easel in front of you, and you have your smock on, ready to paint. At that point you become frightened, you want to chicken out, and you do not know what to do. You might think, "Maybe I should skip the whole thing, have a few more coffees or something." You might have blank sheets of paper and a pen sitting on your desk, and you are about to write poetry. You begin to pick up your pen with a deep sigh—you have nothing to say. You pick up your instrument and do not know what note to play. That first space is heaven, and it is the best one. It is not regarded as regression, particularly; it is just basic space in which you have no idea what *it* is going to do or what *you* are going to do about it or put into it. This initial fear of inadequacy may be regarded as heaven, basic space, complete space. Such fear of knowledge is not all that big a fear, but a gap in space that allows you to step back. It is one's first insight, a kind of positive bewilderment.

Then, as you look at your canvas or your notepad, you come up with a first thought of some kind, which you timidly try out. You begin to mix your paints with your brush, or to scribble timidly on your notepad. The slogan "First thought is best thought!" is an expression of that second principle, which is earth.

The third principle is called man. The man principle confirms the original panic of the heaven principle and the "first thought best thought" of the earth principle put together. You begin to realize that you have something concrete to present. At that point there is a sense of joy and a slight smile at the corners of your mouth, a slight sense of humor. You can actually say something about what you are trying to create. That is the third principle, man.

So we have heaven, earth, and man. To have all three principles, first you have to have the sky; then you have to have earth to complement

the sky; and having sky and earth already, you have to have somebody to occupy that space, which is man. It is like creation, or genesis. This principle of heaven, earth, and man is connected with the ideal form of a work of art, although it includes much more than that. And, to review, all of what we have discussed so far is based on the ground of health, on the idea of complete coolness, and a general sense of sanity.

3. Perception

"There is such a thing as unconditional expression that does not come from self or other. It manifests out of nowhere like mushrooms in a meadow, like hailstones, like thundershowers."

Having discussed the heaven, earth, and man principle in connection with the process of perception in *creating* a work of art, we could discuss what takes place in the individual who *witnesses* a work of art. First we discussed the perception and now we are discussing the perceiver, in that order. By perceiver we mean somebody who witnesses art—or, in fact, witnesses anything. As we discussed yesterday, the process of perception is connected with one's state of mind, the general artistic environment, and the concept of art which has been formed.

In the ordinary nondharmic world, people judge a work of art by the fame and glory of the artist and by what it costs to buy it. Suppose Picasso made a little scratch in the corner of a paper and signed his name underneath—that paper would sell for a lot of money. As artists, you may think that this is the right approach, but it remains very mysterious why, when that same little scratch could have been made by anybody else, you still regard it as a great work of art because it sells for a million dollars. There is a lot of gullibility of that type, particularly in America.

We are also bound by the scientific approach of too many facts and figures. If you teach art in a college, you might be appreciated more for having your facts and figures lined up than for having artistic talent, beyond the neurotic level. This is like saying theologians should know

how many hours Jesus Christ prayed in his lifetime. If they can come up with the statistics, we regard them as great teachers of theology. We find that same problem in many artistic disciplines. Ikebana, or Japanese flower arrangements, are now being measured scientifically to determine which angles are best for arranging branches. The person who puts the branches in the frog, or *kenzan,* at the correct angles is regarded as the best flower arranger. Everything has been computerized. In archery, you look through a sight on your bow so that you can shoot precisely, as though you had a gun rather than a bow and an arrow.

We lose a tremendous amount of spontaneity through relying too much on calculation and scientific artistry, computerized knowledge. Obviously, there is room for some of that: the power and the precision of a work of art can be scientifically measured. But from the practitioner's point of view, the whole thing can be so watered down by that approach that human beings aren't even needed. Robots might produce the best works of art, because robots are better able to be programmed than human beings, who sometimes are not very yielding and who carry their own individualism. A work of art has to be both spontaneous and accurate. Because of your spontaneity, therefore, you could be accurate. The overly scientific approach of having accuracy first and then some kind of programmed spontaneity is problematic. It could lead to the destruction of art.

In order to understand the perceiver or witnesser of art, it is important to discuss perception in general, the way we perceive things based on the principles of *seeing* and *looking.* From the nontheistic point of view of the buddhadharma, we could safely say that first we *look* and then we *see.* Whether we are executing a work of art or witnessing one, first we *look* and then we *see.*

From the theistic point of view, it may be said that first we *see* and then we *look,* which is an interesting reversal, or double-take. The problem with that approach is that when we *see,* we are also trying to *look,* and we have no idea what we are trying to look at. If we look everywhere, we may come up with a good answer—but it is quite likely that we will come up with no answer. We are confused because we first saw something and then we tried to look at it, which is like trying to catch a fish with our bare hands. It is a very slippery situation, trying to catch the phenomenal world in that way. The phenomenal world is not all that pliable. Each time we try to grasp it, we lose it, and sometimes we miss altogether. We might be trying to hold on to the wrong end of the stick. It's very funny, but it's very sad, too.

The notion of looking at things as they are is a very important concept. We cannot even call it a concept, it is an experience. Look! Why do we look at all? Or we could say, Listen! Why do we listen at all? Why do we feel at all? Why do we taste? Why? The one and only answer is that there is such a thing as inquisitiveness in our makeup. Inquisitiveness is the seed syllable of the artist. The artist is interested in sight, sound, feelings, and touchable objects. We are interested and we are inquisitive, very inquisitive, and we are willing to explore in any way we can. We appreciate purple, blue, red, white, yellow, violet. When we see them, we are so interested. Nobody knows why, but purple looks good and sounds good, and red sounds good and looks good. And we discover the different shades of each color as well. We appreciate colors as we hear them, as we feel them. Such tremendous inquisitiveness is the key point in the way we look at things, because with inquisitiveness we have a connection.

We as human beings each have a particular kind of body. We have certain sense organs, such as eyes, noses, ears, mouths, and tongues, to experience the different levels of sense perceptions. And our minds, basically speaking, can communicate thoroughly and properly through any one of those sense organs. But there is a problem of synchronizing body and mind only within the particular area connected with a person's work of art. For example, a person could be a fantastic painter but a bad writer, or a good musician but a bad sculptor. We should not say that we are being punished or that we have no possibilities of correcting or improving that situation. Instead, by training ourselves in the practice of meditation and by training ourselves in the understanding of art as a fundamental and basic discipline, we could learn to synchronize our mind and body completely. Then, ideally speaking, we could accomplish any artistic discipline. Our mind and body have hundreds of thousands of shortcomings, but they are not regarded as punishment or as original sin. Instead they can be corrected and our mind and body synchronized properly. In doing so the first step is learning how to look, how to listen, how to feel. By learning how to look, we begin to discover how to see; by learning how to listen, we learn how to hear; by learning how to feel, we learn how to experience.

To begin with, we need to understand the general projection of the first perception, when you first *look*. The reason you are compelled to *look* is because of your inquisitiveness, and because of your inquisitiveness, you begin to *see* things. Usually, in nontheistic discipline, you *look* first and then you *see* things. *Looking* is *prajna*, intellect; *seeing* is wis-

dom [*jnana*]. After that you find your heaven principle. Heaven is the definite discovery of the product of what you are looking for, what you are seeing. This analysis is very scientific; it has been described in the *abhidharma* teachings of Buddhist philosophy. When sense objects and sense perceptions and sense organs meet, and they begin to be synchronized, you let yourself go a little further; you open yourself. It is like a camera aperture: your lens is open at that point. Then you see things, and they reflect into your state of mind. After that, you make a decision that what you've seen is either desirable or undesirable—and you make further decisions after that. That seems to be the basic idea of how a perceiver looks at a work of art.

The heaven, earth, and man principle could be applied to this process of perception. Having looked, you see the big thing first. This does not mean that you see a monolithic object or hear a monolithic sound: you may see a little flea or a gigantic mountain—from this perspective, they are the same. It is simply the first perception of *that*, which sets the foundation. That is the heaven principle. In discussing the creation of art, first thought is the second principle, or earth. But from the viewpoint of the perceiver of art, first thought is heaven. That big thing, that initial perception, breaks through your subconscious gossip. Sometimes it is shocking, sometimes it is pleasant, but whatever the case, a big thing happens—*that*—which is heaven. In the ikebana tradition, heaven is the first branch you place in your *kenzan*, the principal branch. It may be a breakthrough, maybe not quite.

After that, you have earth, which is a confirmation of that big thing. Earth allows the heaven principle to be legitimate, in the sense that it is your initial perception which allows you to do that second thing. As this second action is in accordance with your first perception, therefore your initial perception becomes legitimate and complementary.

Having organized heaven and earth together, you feel at ease and comfortable. So you add the man principle as the third situation, which makes you feel, "Whew! Wow, I've done it!" You could generate little messages or little bits of playful information, which makes the whole situation simple and straight—and also jazzes it up, decorates it. All these little touches are expressions of inquisitiveness, as well as expressions that because you looked, because you listened, therefore you saw, therefore you heard.

We are trying to work with that general principle of heaven, earth, and man. It takes a long time to learn not to jump the gun. Usually we are very impatient. We have a tremendous tendency to look for a quick

discovery or for proof that what we have done is good, that we have discovered something, that we have made it, that it worked, that it is marketable, and so forth. But none of those impatient approaches show any understanding of looking and seeing at all.

The general approach of heaven, earth, and man is that things have to be done on a grand scale, whether you like it or not, with tremendous preparation. Ideally, you have to experience the basic ground in which situations are clean, workable, and pliable, in which all the implements are there. You do not try to cover up when an emergency occurs: you do not run to the closest supermarket to purchase Band-Aids or Scotch Tape or aspirin.

For the general work or discipline of art, both as students perceive it and as artists conduct themselves in its creation, there needs to be a good environment. The preparation of the environment is very important. In order to ride your horse, you have to have a good saddle as well as a good horse, if you can afford to buy one. In order to paint on canvas, you have to have a good brush and good paints and a good studio. Trying to ignore this inconvenience, working in your mouse hole or in your basement, might have worked for people in medieval times, but in the twentieth century it doesn't. If you take that approach, you might be regarded as a veteran because you were willing to survive the dirt in order to present your glorious art, but unfortunately, very few artists who live like that come up with good results. Instead, many of them develop tremendous negativity and resentment toward society. Their resentment starts with their landlords, because they have had to work on their fantastic works of art in cold, damp basements for so many hours. Then they complain to their friends, who have never acknowledged or experienced what they have gone through. Then they begin to develop further complaints toward their world in general and toward their teacher. They begin to build up all sorts of garbage and negativity that way.

Some room for self-respect in a work of art is absolutely necessary. Furthermore, the implements we use in creating a work of art are regarded as sacred. If we were completely oppressed, if we had been persecuted to the extent that we could not even show our work of art, we might have to do it in a dungeon—but we are not facing that yet. We can afford to rise and take pleasure in what we are doing. We can have respect for what we are doing and appreciate the sacredness of the whole thing.

In discussing the principle of heaven, earth, and man, we are working on how the structure of perception relates with one's sense fields, so to

speak. We are talking in terms of a basic state of mind in which we have already developed a notion of ourselves and our communication with others. When others are working with us and we are working with them, there is a general sense of play back and forth and also some sense of basic existence. Where do such situations come from? They come from our practice of meditation. We no longer regard a work of art as a gimmick or as confirmation, it is simply expression—not even self-expression, just expression. We could safely say that there is such a thing as unconditional expression that does not come from self or other. It manifests out of nowhere like mushrooms in a meadow, like hailstones, like thundershowers.

The basic sense of delight and spontaneity in a person who has opened fully and thoroughly to himself and life can provide wonderful rainbows and thundershowers and gusts of wind. We don't have to be tied down to the greasy-spoon world of well-meaning artists with their heavy-handed looks on their faces and overfed information in their brains. The basic idea of dharma art is the sense of peace and the refreshing coolness of the absence of neurosis. If there is no refreshing coolness, you are unable even to lift up your brush to paint on your canvas. You find that your brush weighs ten thousand tons. You are weighted down by your depression and laziness and neurosis. On the other hand, you cannot take what's known as "poetic license," doing everything freestyle. That would be like hoping that the rock you throw at night will land on your enemy's head.

4. The Mandala of the Four Karmas

"The entire Tibetan vajrayana iconography is based on this particular mandala principle. It works and did work and will work."

The principle of heaven, earth, and man could be illustrated by means of a series of diagrams.

The heaven, earth, and man arrangement can exist on the basis of two situations. The first is that the innate nature of heaven, earth, and man exists in us as basic talent. This innate nature that we are going to work on is connected with a particular shape, the circle. The basic, innate nature of our existence and sense of perception is the circle.

DIAGRAM 1

Then there is the sense of first dot, which is expanded with a line coming from that dot. First dot is best dot! The basic idea here is that the blank space is heaven and the first dot is earth. On the other hand, we could also talk about the whole thing, the first dot surrounded by a circle, as being the heaven principle.

PACIFYING 1

Within that first dot concept, we have a basic circle, as you can see. The circle is the idea of the basic innate nature of the heaven, earth, and man principle. The outer circle represents mind, and the inner circle represents energy. So the perimeter is thought, and the inner circle is a particular type of energy.

According to the vajrayana tradition, four basic types of energies exist, called the four *karmas*, or actions. The round shape of the inner

circle represents gentleness and innate goodness. This is the first karma, which is the principle of peace, or pacifying. Innate goodness possesses gentleness and is absent of neurosis. These things could be experienced.

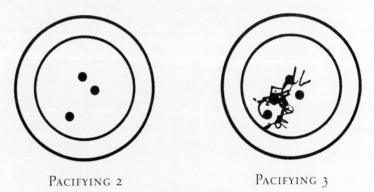

PACIFYING 2 PACIFYING 3

Suppose we place the heaven, earth, and man principle on this particular ground. The placement of heaven, earth, and man complements the circles, particularly the inner circle. There is a sense of no neurosis and a sense of gentleness. But if we have more than this happening, it becomes very confusing. There is no gentleness because there are so many things going on.

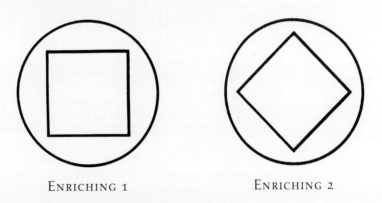

ENRICHING 1 ENRICHING 2

Again you see a circle on the perimeter, representing manifested mind, the mental state of being, but in this case there is a square in the middle, which is the energy field of the second karma, the enriching principle.

If we turn it, it gives an entirely different effect. We begin to realize that there are too many sharp angles. But if we keep it the original way, it has a sense of being, of harmony, a well-settled situation. Enriching is

the intrinsic energy of our state of mind. It is the idea of dignity, or in Tibetan, *ziji*.

ENRICHING 3

Within that enriching situation, we could have a perfect heaven and earth side by side, which complements the squareness of enriching, the earthiness of it. And we could even put a little man in it; there is still a sense of dignity.

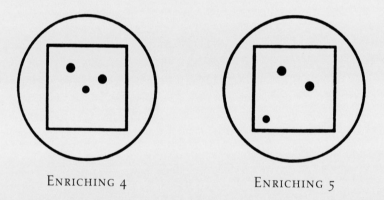

ENRICHING 4 ENRICHING 5

If we want to place more emphasis, we could change it like this [as in Enriching 4]. Or we could make the man principle larger [as in Enriching 5]. Perfect! It possesses dignity.

Now we have more or less a half circle, which is the idea of the third karma, or magnetizing. Within our intrinsic nature, magnetizing is basic richness. It is also the idea of letting go, daring to let go. [See Magnetizing 1.]

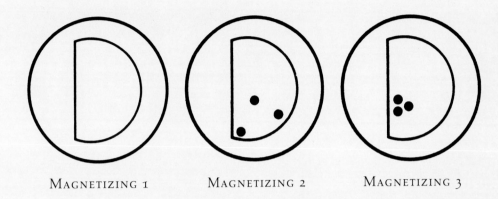

MAGNETIZING 1 MAGNETIZING 2 MAGNETIZING 3

The heaven, earth, and man principle goes along with that. It is the idea that once there is a sense of richness and of no poverty, we can let go, give away, be generous. This is the source of the magnetizing principle. [See Magnetizing 2.]

On the other hand, if we put everything together and jump off the edge, we have miserliness, holding on to the purse strings very tightly and not wanting to give anything away. We want to jump off the cliff before we have to give somebody even half a penny. [See Magnetizing 3.]

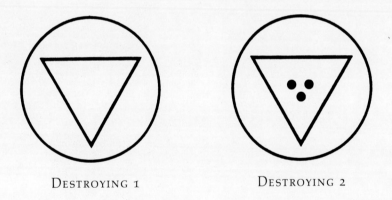

DESTROYING 1 DESTROYING 2

The fourth karma is the heavy one—destruction. Its basic, inherent nature is fearless. The notion of balance comes along with that, because if there is too little fearlessness, you might be a coward, and if there is too much fearlessness, everything is too intellectual. So we have a basic point of balance. [See Destroying 1.] We could place heaven, earth, and man right in the middle. If we organize it that way, there is lots of humor as well as fearlessness. [See Destroying 2.]

Having introduced the four karmas, we can now discuss the manifestation of the four karmas. This has to do with how we actually work with these four principles. The idea of fully manifesting the karmas is represented by placing the characteristic shape of each of the four karmas within a square background.

PACIFYING

The square represents manifestation. In a traditional mandala diagram, within the architecture of the mandala, the square represents the courtyard. It is also the earth principle. Previously we discussed the circle as heaven, or the "first thought" principle. Now we have an earth principle to go with it. The inner drawings are connected with the man principle. So we have heaven, earth, and man that way.

The circle within the square is connected with the first karma, pacifying. It represents the cooling off of neurosis. Traditionally, to relate to the principle of cooling off, we have to enter from the east, which in this case is down. [See line at bottom of circle. In Tibetan mandalas, east is below, west is on top, north is to the right, and south is to the left.] Entering from the east, we develop a sense of peace and coolness. In the middle, slightly off-center, is a cool situation, which cools off the boredom and heat of neurosis. [Vidyadhara draws symbols in blue.] It is pure, blue, cool. So the original manifestation, that of pacifying, is gentleness and freedom from neurosis. It is pure and cool.

ENRICHING

Within the same square shape, the same kind of wall, representing manifestation, we also can place the enriching principle, which is basically the absence of arrogance and aggression. We usually enter this mandala from the south. [See line at left.] Entering from the south, we begin to make a connection with richness. We no longer regard the square as a wall, but rather as our conquest of any areas where there might be arrogance. Arrogance is overcome, it is transparent. To make it clearer, I'll put a little red into the paint; plain yellow seems rather weak, although yellow does make sense in representing the absence of arrogance.

MAGNETIZING

The basic principle of magnetizing is overcoming poverty. We approach it from the west. [See line at top of diagram.] Maybe this is too mysterious, but here are heaven, earth, and man. [Vidyadhara draws symbols in red on diagram.] It is free from poverty. It is very hard to say *why* all these things work, but it makes sense when you look at them properly, when you have some sense of visual perspective. So, ladies and gentlemen, it is up to you, and it is very traditional.

DESTROYING

[Vidyadhara draws symbols in green.] In the manifestation of the fourth karma, destruction, we enter this particular energy field from the north. [See line at the right.] The background may be slightly problematic because it is supposed to come down a little further, but it gives you some idea of the principle of this karma, which is the destruction of laziness.

MANDALA 1

If we put all of the second series of diagrams together, we begin to have some idea of the whole thing. East represents awake; south represents expansion; west represents passion or magnetizing; north represents action. That seems to be the basic mandala principle that has developed.

[Vidyadhara overlays original dot and circle over the four.] On top of that we could add two lines that represent the psychological state of being; that is how far we could get into it. We are working toward the center and then, having become a practitioner, we go through the whole thing. [Vidyadhara draws line completely across diagram.] That is the

basic visual diagram of the whole path, starting from hinayana, through mahayana, into vajrayana.

First of all, students enter from the east because they want to be relieved of their pain, they want to be peaceful. They enter from the south because they would also like to have some sense of richness in them, having already entered the path. They enter from the west because they would like to make a relationship with their community members, the sangha. They enter from the north because they would also like to activate or motivate working with the sangha. So apart from the artistic arrangement, there is a sociological setup that goes with the mandala principle as well. We can actually operate from this basic mandala principle—in flower arranging, horseback riding, dishwashing, and all the rest.

This final diagram is everything put together. It looks rather confusing in the middle, but it makes sense because we have the principles, and [displaying original dot and circle] we have the psychological state of being—why we want to become sane at all. It might look very confusing, but it might make sense. The entire Tibetan vajrayana iconography is based on this particular mandala principle. It works and did work and will work. It is quite obvious that it is possible to work with it.

MANDALA 2

There is always room to find your spot [the heaven principle]. And then from that particular spot you can branch out, which is the earth and man principle. Don't panic. We can do it that way.

This discussion is not as abstract as you might think; it is more visual. It is worthwhile looking into these diagrams and colors as you study the basic principles. You might find these diagrams confusing, but if you look at them and develop your own diagrams and play with them, you might find that there is a reference point, and that the whole thing makes sense.

5. Discipline

"The concept of synchronizing body and mind is a total one,
related to whatever work of art you execute
or whatever life you lead."

As you know already, the notion of space and its relationship to the artist's point of view is very important. The temperature of that space, the coolness and absence of the heat of neurosis, also is very important as the background to our discussion. With that foundation, we also have the possibility of no longer freelancing, but educating ourselves through discipline, which is one of the foremost factors in the growing-up process. It all becomes a further learning situation: working with our world, our life, and our livelihood, as well as our art. Art is regarded as a way of life altogether, not necessarily as a trade or business.

We already talked about having a correct understanding of the work of art and not polluting the whole world by our artwork. We are trying to work to create a decent society where the work of art is respected and regarded as very sacred and does not become completely mercenary. On the other hand, certain artists have wanted to expand their vision and relate with as many people as possible. Quite possibly they did have a genuine reference point, and hundreds of thousands of people came along and appreciated their works of art. The question of how much restraint we should use and how much we should expand our vision and our energy to reach others is a very tricky one.

We are going to go back and reiterate the concept of heaven, earth, and man once more, in connection with what we have discussed already. The heaven, earth, and man principle that we are going to discuss will be accompanied by some on-the-spot calligraphies based on the principles of the four karmas: pacifying, enriching, magnetizing, and destroying.

In heaven, earth, and man, the first principle, as you know already, is heaven. It might be interesting for you to realize the psychological and physical implications of that principle in regard to executing a work of art. To begin with, the artist should have a feeling of connection with the brush or the musical instrument. Whatever medium you might use, you have a reference point to the body. This is connected with the idea of synchronizing body and mind. The concept of synchronizing body and mind is a total one, related to whatever work of art you execute or whatever life you lead. The way you dress yourself, the way you brush

your hair, the way you brush your teeth, the way you take your shower or bath, the way you sit on your toilet—all of those basic activities are works of art in themselves. Art is life, rather than a gimmick. That is what we are talking about, not how the Buddhist concept can be saleable and merchandised. I would like to remind you again and again, in case you forget, that art in this sense includes your total experience. And within that the mind and body are relating together.

The suggestion that you practice sitting meditation before you execute a work of art is obviously a good one, but that does not mean that you have to become a Buddhist. It is simply that you can give yourself space, a gap where you can warm up and cool off all at once. That is ideal. If you do that, it will bring with it the notion of extending your mind by working through your sense perceptions. To extend our minds through our sense perceptions, we have to *use* our sense perceptions; in other words, use our bodies as vehicles. We could use the analogy of photography. We have a particular type of film, which represents the mind, and we put the film into a camera, which has different apertures and speeds, all of which represent the body. When the film and the camera—mind and body—coincide, then we at least have a good exposure: the film will react to light and we will have good, clear photography. But beyond that, there is also how we frame what we see, what kind of lens we use, and what composition we have in mind. The way we frame the picture is connected with the four karmas. It comes up once we have the settings and the film already in order.

Synchronizing body and mind is always the key. If we are artists, we have to live like artists. We have to treat our entire lives as our discipline. Otherwise we will be dilettante artists or, for that matter, schizophrenic artists. That has been a problem in the past, but hopefully we can correct that situation, so that artists live like the greatest practitioners, who see that there is no boundary between when they practice art and when they are not practicing art. The post-art and the actual art experience become one, just as postmeditation and meditation begin to become one. At that point the meditator or artist has greater scope to relate with his or her life completely and thoroughly. He or she has conquered the universe—overcome it somewhat. There is a tremendous cheerfulness and nothing to regret, no sharp edges to fight with. So things become good and soothing and very workable—with a tremendous smile.

Another way of looking at the heaven principle is as total discipline, which is free from hope and fear. The general experience is no hope, no

fear, and it comes in that particular order: first no hope, then no fear. At first we might have no idea what we are going to execute as our work of art. Usually, in executing art, we would like to produce something, but we are left with our implements, our accoutrements, and we have no idea how we are going to proceed or which tool to begin with. So no hope comes first. No hope comes first because we are not trying to achieve anything other than our basic livelihood. After that comes no fear, because there is no sense of an ideal model we should achieve. Therefore, there is no fear. Very simply, we could say, "We have nothing to lose."

When we have that attitude and motivation, we are victorious, because we are not afraid of falling into any dungeons, nor do we hope for any particular high point. There is a general sense of even-mindedness, which could also be called genuineness or decency. *Decency* is a very important word for artists because when we say, "*I'm* an artist," there is always a tinge of doubt. Maybe we are not telling the truth, but we might be making something up. So the whole principle of decency is trying to live up to that particular truth. We might be hopeful and we might be fearful. For instance, in modern society, many people are afraid of truth. That is why we find so many law firms willing to protect a lie. We can employ lawyers to support our lies and twists on the truth. A lot of lawyers make a lot of money that way. So lawyers and artists could both be questionable.

Being without fear and without hope, which is the heaven principle, provides a lot of freedom, a lot of space. It is not freedom in the sense of blatantly coming out with all sorts of self-styled expressions of imprisonment. Some people regard that as an expression of freedom. If they can clearly express their imprisonment, they begin to feel that they have made some kind of breakthrough. That can go on and on and on. People tried that approach in the fifties and sixties quite a lot in America. But they came back to square one in the seventies. Without getting into too much politics, here the notion of freedom is a letting-go process. There is enough room to express yourself. That is the definition of freedom. There is room for you to demonstrate your free style—not that of imprisonment, but the possibility of freedom from imprisonment altogether.

The earth principle comes after that. Earth is usually regarded as very solid and stubborn, as something we think we can't be friendly toward. Digging soil takes a lot of effort and energy. But here there is a twist of logic: the earth principle is unobstructed; there is no obstacle. But we

should not misunderstand this, thinking that the earth is pliable, that there is no ground to stand on, or that the earth will change. It all depends on our trip—or trips. Earth is somewhat solid, but at the same time earth can be penetrated very easily, with no obstructions. This is a very important point. Because it is related with the heaven principle of no hope and no fear, that actually brings down raindrops onto the earth, so earth can be penetrated, worked on. Because of that, there are possibilities of cultivating the earth and growing vegetation in it, and using it as a resource for cows to graze on. The possibilities are infinite.

But something is missing from the logic of the relationship between heaven and earth. The heaven principle of no hope and no fear could become very dry and too logical. We need some kind of warmth coming from heaven as well. If you put no hope and no fear together, that mounts up almost mathematically into tremendous warmth and love. Therefore when we have heaven, we could have raindrops coming down, making a sympathetic connection with earth. When that connection takes place, things are not so cut and dried. The more that relationship comes down from heaven, the more the earth begins to yield. Therefore the earth becomes gentle and soft and pliable, and can actually produce greenery.

Then we have man, which is connected with both those principles: being without hope and without fear, and being unobstructed. Man can survive with the mercy of heaven and earth and have a good relationship with both of them. It is almost a traditional, scientific truth that when heaven and earth have a good relationship, man has a good relationship with them. When heaven and earth are fighting, there is drought and starvation. All kinds of problems come from the conflict between heaven and earth. Whenever there is that kind of conflict, men and women begin to have doubts about their king, who is supposed to have the power to join heaven and earth but is not quite able to do so, as in the Judeo-Christian story of King David. Whenever there is plenty of rain and plenty of greenery, men feel that their king is worthwhile.

The man principle is known as simplicity: freedom from concepts, freedom from trappings. Men could actually enjoy the freedom from hope and fear of heaven and the pliability of earth. Therefore they could live together and relate to one another. The idea of the sky falling on their heads is no longer a threat. They know that the sky will always be there and that the earth will always be there. There is no fear that the sky and earth are going to chew man up and eat him. A lot of the fear of natural disasters comes out of man's distrust of heaven and earth and of

the four seasons working harmoniously together. When there is no fear, man begins to join in, as he deserves, living in this world. He has heaven above and earth below and he begins to appreciate the trees and greenery, bananas, oranges, and what have you.

In connection with the heaven, earth, and man principle, we have a fourth category, that of the four karmas. We are free from acceptance and rejection when we begin to realize pacifying, enriching, magnetizing, and destroying as the natural expression of our desire to work with the whole universe. We are free from accepting too eagerly or rejecting too violently; we are free from push and pull. In Buddhism that freedom is known as the mandala principle, in which everything is moderated by those four activities. You can express heaven and earth as pacifying or enriching or magnetizing or destroying: all four karmas are connected with joining heaven and earth. Because we are free from acceptance and rejection there is a basic notion of how we can handle the whole world. So the idea of the four karmas is not so much how we can handle ourselves, particularly, but it is how we can relate with the radiation coming out of the heaven, earth, and man principle. For example, if you are sitting on a meditation cushion, you can see how large a radius you cover around yourself and your neighbors, and the relationships connected with that.

At this point we could execute a few calligraphies connected with the heaven, earth, and man principle and with the four karmas. The brush I am using tonight is not trained yet—it's been waiting here a long time in this hot climate, and it hasn't been soaked in water yet. But we'll see what we can do. [Vidyadhara begins to execute calligraphies.]

First, we go through the process of pacifying, in connection with the heaven, earth, and man principle.

With enriching we begin from the south. It takes time to do the calligraphy in the form of a rabbit's jump.

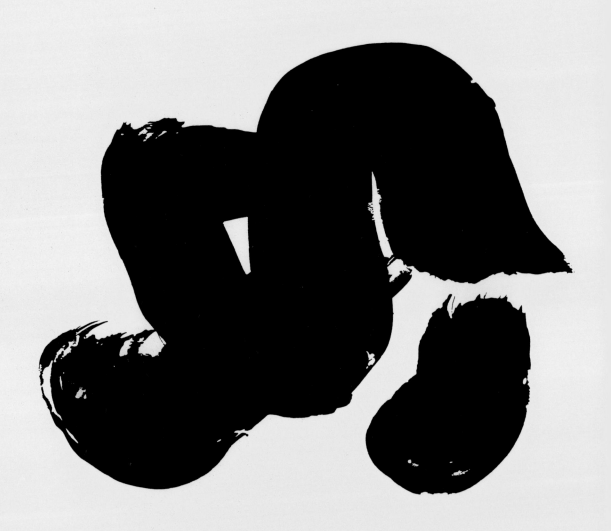

Magnetizing is very delicate and very difficult, quite difficult. I wonder if I should do it at all. It begins from the west. The sense of seduction lies in the rhythm; at the same time, it is genuine seduction.

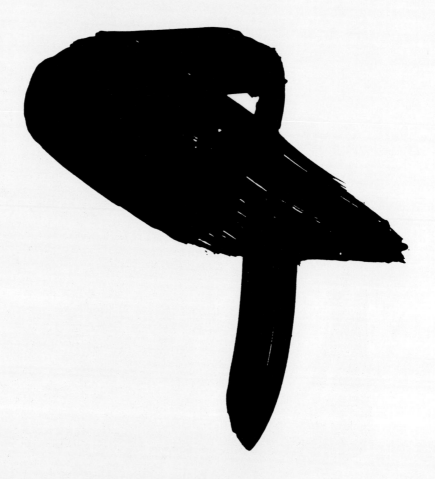

Now destruction. It's very simple. We take our brushstroke from the north, the direction of the karma family. It is clean cut, as if you were running into Wilkinson's sword—or for that matter, Kiku Masamune [a brand of *sake*]. It cuts in all directions. Very simple.

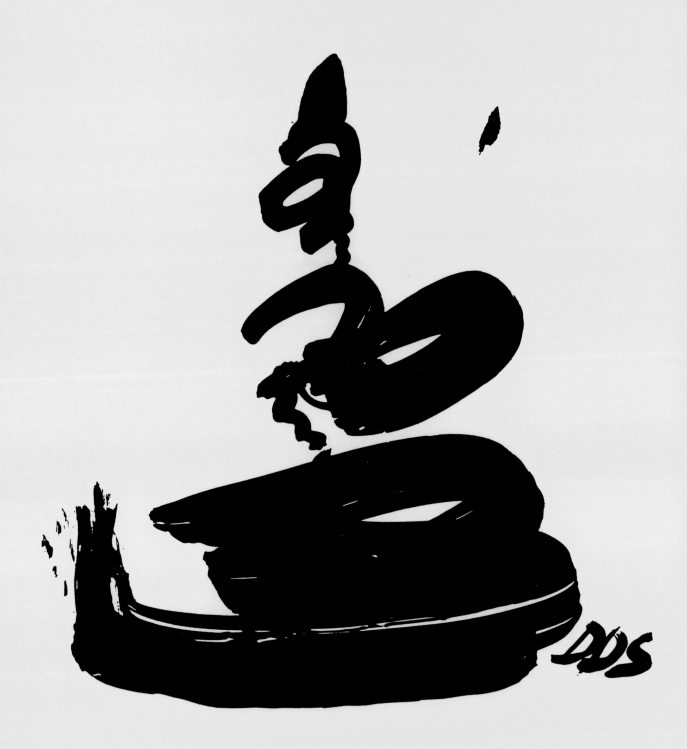

We could execute a calligraphy for joining heaven and earth together.
It might be a little calligraphy, quite a tiny one, maybe a very humble
one. We begin in the west and go toward the east.

6. Art and Society

*"In dharma art, what we are trying to do is to tame
our society, including ourselves."*

On a larger level, dharma art is connected with the idea of how to clean up setting-sun vision [the small world of aggression, passion, and ignorance] and transform it into what is known as Great Eastern Sun vision. That is our purpose altogether. The idea of Great Eastern Sun in this context has nothing to do with chauvinism or aggression. Ironically, the words that we have come up with to describe Great Eastern Sun—humbleness and genuineness—are the opposite of chauvinism and aggression. Other qualities associated with Great Eastern Sun are a sense of precision, warmth, kindness, and gentleness. Such humbleness, gentleness, kindness, and warmth are all very important for us as artists and as ordinary decent human beings.

Another term connected with dharma art is "positive arrogance." From the dictionary's point of view, positive arrogance sounds contradictory, but from an experiential point of view, there is a lot of room for positive arrogance. In fact, the whole heaven, earth, and man principle is a presentation of positive arrogance. At the beginning, we might not have any idea what we are going to execute on our drawing boards, our notepads, or on our canvases. We might feel lost. But something suddenly perks us up, which is positive arrogance. That arrogance has nothing to do with chauvinism. Chauvinism is one-sided: you support either this side or that side, this or that, me or them. With positive arrogance, chauvinism doesn't come into the picture at all.

The basic vision is that we would like to organize and create a decent society. We could be slightly, positively arrogant by even saying "enlightened society." Can we take that much arrogance? Shall we say it or not? We are not particularly afraid of saying enlightened society; at the same time, we do not want to offend any of you. You might think that enlightened society means something very haughty and unreasonable and aggressive. Obviously we have to go step by step in creating an enlightened society. We can't approach it like putting up a tent on the spot, right away. Creating such a society will be a journey for each one of us, myself included. It will be a very slow journey, to begin with. The first part of the journey will be very, very slow, and it will be difficult to

see the progress we are making. We might question whether we are making progress at all. But as we take this very slow journey, we begin to realize that progress is not a question anymore. We begin to see, "Ah, something's taking place!" There is a flash of goodness taking place in our perspective. We begin to develop a wonderful sense of head and shoulders as we practice, as we become authentic artists. We begin to take pride in that. That pride could be connected with enlightenment.

We can make the journey. We do not fool ourselves with concepts and ideas. There is evidence for that in the past, and we can always refer back to the two-thousand-five-hundred-year history of Buddhist success, Buddhist vision. Buddhist vision has always been built on this kind of slow journey, which finally makes sense and begins to create tremendous sparks, tremendous explosions, unexpectedly. Sometimes you might think that certain areas or corners are not worth investigating, and you just let them go. But suddenly, to your surprise, you begin to see that the very corner you have neglected has a spark, here and there, all the time. That spark is known as the spark of enlightened society.

I would like you to develop basic gentleness and kindness in yourselves as artists and in your audience, whoever they may be. To begin with, please don't push your trips, and please be gentle to yourselves. Every calligraphy you have seen and all the explanations you have heard represent that vision of gentleness, which has several shades: gray gentleness, maybe silver-gray; red gentleness, very red like an open wound; gray-green gentleness, which complements the redness of the flash and the basic silver gray, and in turn the redness begins to shine through. Suppose you have an arrangement of colors which is basically silver gray, and you add some areas of green-gray. It sounds terrible, doesn't it? But if you actually do that in a color arrangement, you will find that it produces a dynamic situation.

The four karmas are a very interesting point of reference. As you know, the shapes of the four karmas are connected with the colors blue, yellow, red, and green. If we simplify that color perspective by combining those four colors into two—the ideal, traditional result is lemon yellow and purple. Those two colors were the imperial colors in the courts of China, Japan, Korea, and India, and in the empire of Ashoka as well. The lemon yellow [number 116 in the PMS color chart] is traditionally a high-class yellow, connected with strength and the father, or king, principle. And the particular shade of purple [number 266 in the PMS color chart] is considered to be a high-class purple. It is the ultimate idea of the feminine, or queen, principle. When the masculine principle and the feminine principle are joined together, you have the

complete accomplishment of all four karmas—pacifying, enriching, magnetizing, and destroying. Everything is accomplished that way. You might wonder why and how everything is accomplished in that way. I don't think I can actually give you any answer to that. Obviously I could cook up some scientific reasons, but I don't think that is the point. The idea is that you should actually see those colors and put them together.

The whole purpose is to soothe aggression and passion and ignorance. Everybody wants to learn so much and wants to do their best. Such enthusiasm and exertion might be all right, but on the other hand, it could become a killer. If you relate with situations too intensely, you begin to lose the gentleness and genuineness which are the essence of art. In dharma art, what we are trying to do is to tame our society, including ourselves, if I may say so. We could be more decent and less experimental, in the sense that we don't use a lot of aggressive ways to try to prove our theories. Instead, we learn to relax and settle down into our discipline, whatever we are doing—whether we are making films or riding horses, whether we are photographers, painters, musicians, landscapers, or interior decorators. In this way of thinking, a linguist or scientist is also an artist. Scientific research is regarded as a work of art because scientific discipline also needs tremendous gentleness. Otherwise it becomes a way of experimenting with the universe, in which you cut everybody down and open their lungs and hearts on the clean carpet of your drawing room.

We have tremendous integrity and a scheme, if you like, to make our world and our understanding workable. The only thing we want to do is to invite human beings to take part in something very real and gentle and beautiful, all at the same time. There is often a problem with the traditional scientific or business mentality, because although it might suggest how to succeed, it lacks knowledge of how to make friends, or how to be warm. That becomes a tremendous obstacle. When we begin to realize how to become warm and to make friends with our world— when that kind of breakthrough takes place—then there is no problem at all in introducing buddhadharma into our art.

The essence of buddhadharma is compassion and kindness, one of the fundamental components of enlightened mind. Enlightened mind consists of *prajna*, or "discriminating awareness," and *karuna*, or friendship and kindness. When there is both kindness and discriminating awareness, you have a complete outfit, so to speak. You have acquired a pair of spectacles with a good prescription and also clean. Then you can look through them at your world.

We have to be so genuine and gentle. Otherwise there is no way to work with the universe at all. You have a tremendous responsibility: the first is to yourself, to become gentle and genuine; the second is to work for others in that same way. It is very important to realize how powerful all of us are. What we are doing may seem insignificant, but this notion of dharma art will be like an atomic bomb you carry in your mind. You could play a tremendous role in developing peace throughout the world.

CALLIGRAPHIES

བློ་ཆོས་སུ་འགྲོ་བར་བྱིན་གྱིས་རློབས།

ཆོས་ལམ་དུ་འགྲོ་བར་བྱིན་གྱིས་རློབས།

ལམ་འཁྲུལ་པ་སེལ་བར་བྱིན་གྱིས་རློབས།

འཁྲུལ་པ་ཡེ་ཤེས་སུ་འཆར་བར་བྱིན་གྱིས་རློབས།།

ཨཱུྃཿ

Grant your blessings so that my mind may be one with the
 dharma.
Grant your blessings so that dharma may progress along
 the path.
Grant your blessings so that the path may clarify confusion.
Grant your blessings so that confusion may dawn as wisdom.

AH

"The Four Dharmas of Gampopa" is a traditional daily chant, evoking
the heart of the spiritual path in a few pithy phrases.

ཨ་ནམ་མཁའ་གང་བའི་མི་བསྐྱོད་རྡོ་རྗེ།

A! Mikyö Dorje fills the whole of space.

This calligraphy and the three that follow are lines in a stanza written by Mikyö Dorje, the eighth Karmapa, quoted by Trungpa Rinpoche in *The Sadhana of Mahamudra*.

ཧོ་འོད་ཟེར་འགྱེད་པའི་རོ་རྗེ་དགའ་བ།

HO! He is the vajra joy which sends out luminous light.

ཧཱུྃ་པོ་ཏུ་འབར་བའི་དབྱངས་ཅན་ཉུས་པ།

HUM! He is the energy of music and lord of messengers.

ཨོཾ་རྗེ་མ་བྲལ་བའི་ཕྲིན་ལས་དྲག་པོ།

OM! He is the wrathful action which cleanses all impurities.

"Always meditate on that which is most difficult. If you do not start right away, the moment a difficulty arises, it is very hard to overcome it."

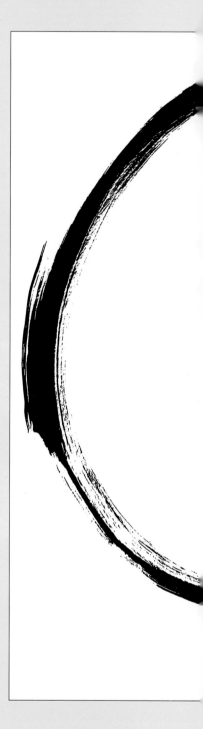

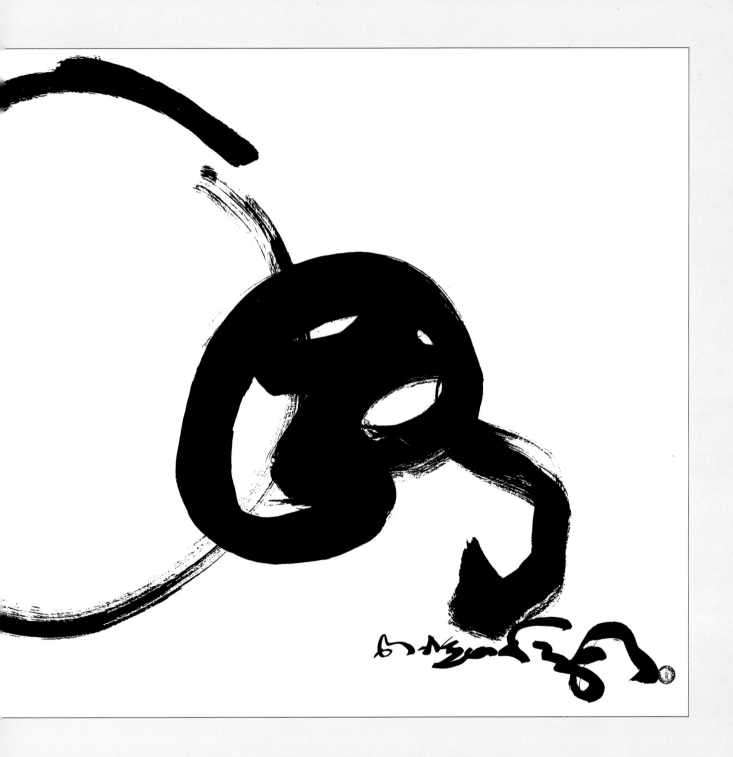

"A friend without inside or outside
And a rock that is not happy or sad
Are watching the winter crescent moon
Suffering from the bitter wind."

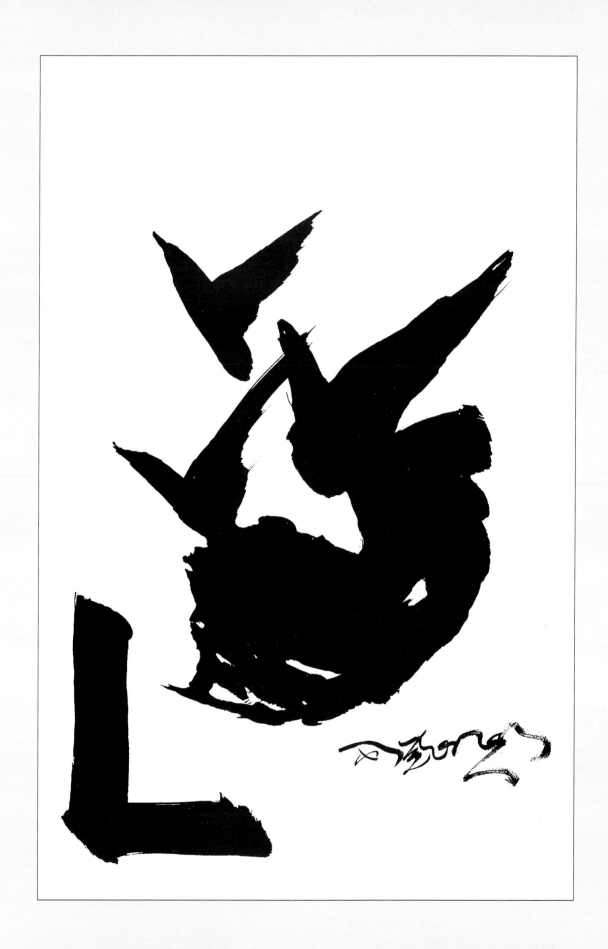

"When I meditate in the cave
rock becomes transparent.
When I met the right consort
my thought became transparent."

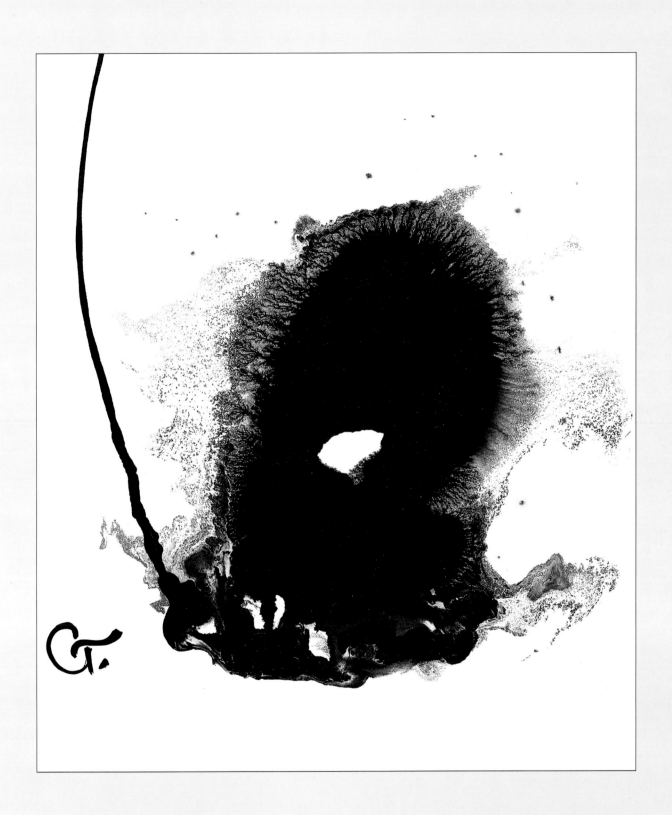

"Glory be to the blade of grass
That carries heavy frost
Turning into dew drop."

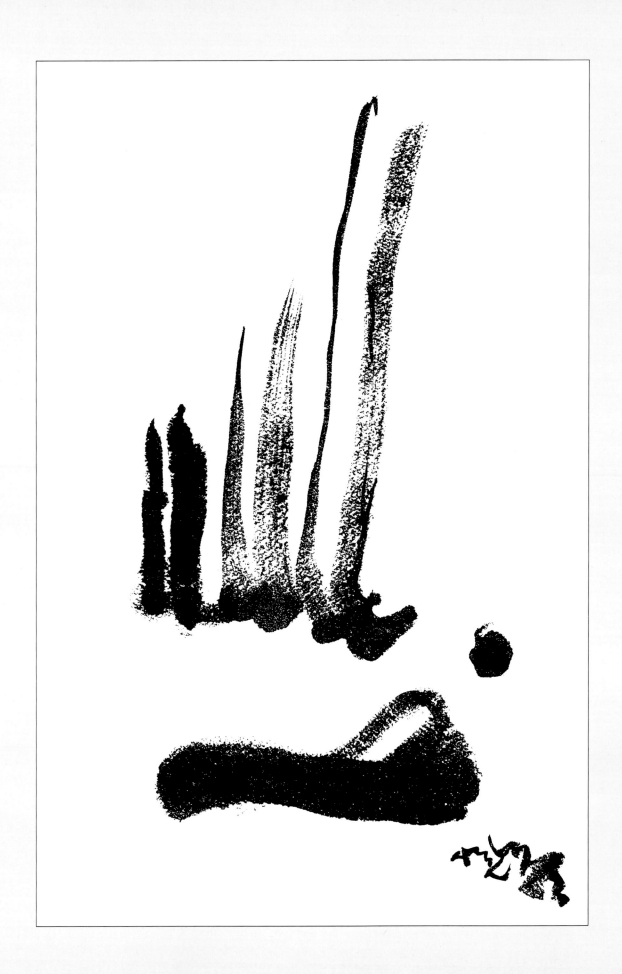

"The lonely bird lived all his days
In a place apart, yet did not know
Peace or the dwelling-place of peace.
But when the face of loneliness
Is known to you, then you will find
The Himalayan hermitage."

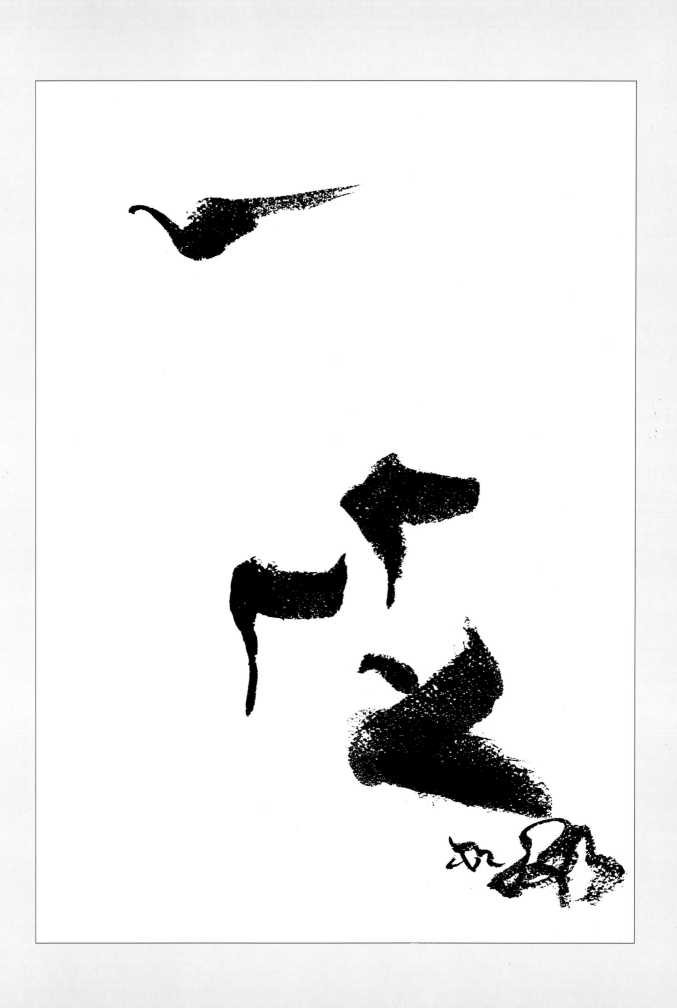

"You take refuge in the Buddha not as a savior—not with the feeling that you have found something to make you secure—but as an example, as someone you can emulate. . . . Then you take refuge in the teachings of the Buddha—the dharma—as path. . . . Having taken refuge in the Buddha as an example and the dharma as path, you take refuge in the sangha as companionship. . . . The Three Jewels—the Buddha, the dharma, and the sangha—become a part of your existence and you thrive on that, you work with that, you live on that."

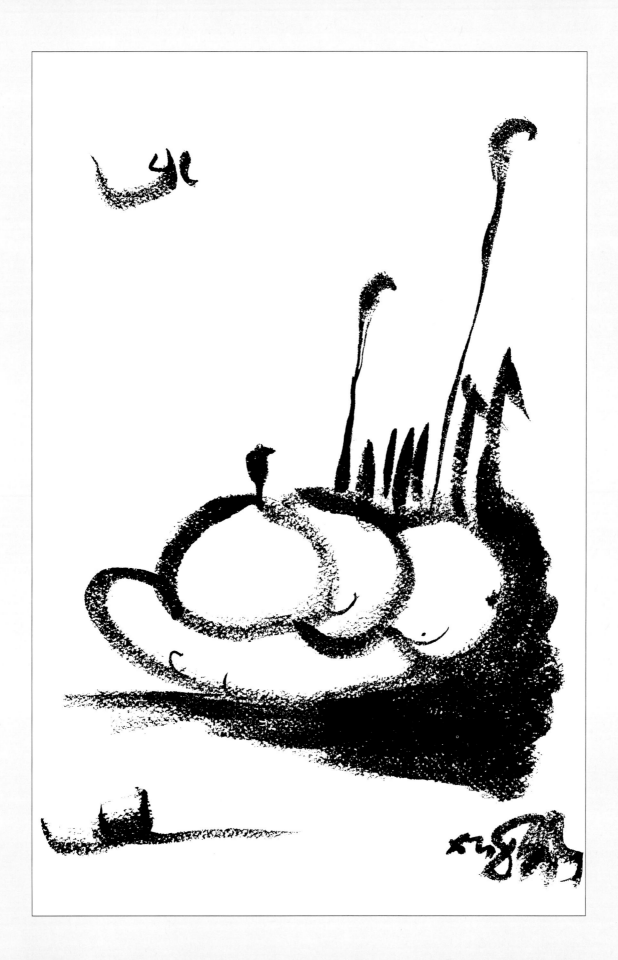

མ་སྐྱེས། སུས་མ་བྱས་པས་ཁྲོད་མ་རྗོད།

Unborn. Since nobody created it, don't speak of it.

སུས་མ་བཀག་པས་མ་འགགས་པ།

Since nobody stopped it, it's unceasing.

བཙོན་ལས་གྲོལ་བས་ཅིར་ཡང་མིན།

Since it's effortless, it's nothing whatever.

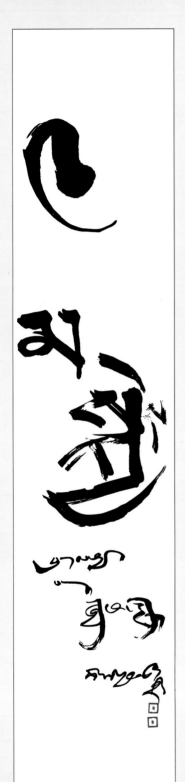

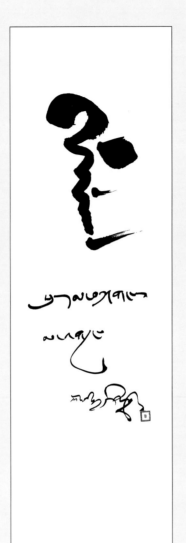

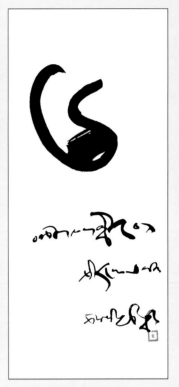

ཐ་མལ་གྱི་ཤེས་པ།

Ordinary mind

"In the awakened state the colorful, luminous qualities of energies become more vivid. If we see a red flower, we not only see it in the absence of ego's complexity, in the absence of preconceived names and forms, but we also see the brilliance of that flower."

ཧཱུྃ༔

རྡོ་རྗེ་བྲག་གི་ཁྲི་འཕང་དུ།
རྡོ་རྗེ་འཛིན་པའི་ཡེ་ཤེས་འཁྲུངས།

HUM

On a vajra throne of stone
The wisdom of the vajra holder is born.

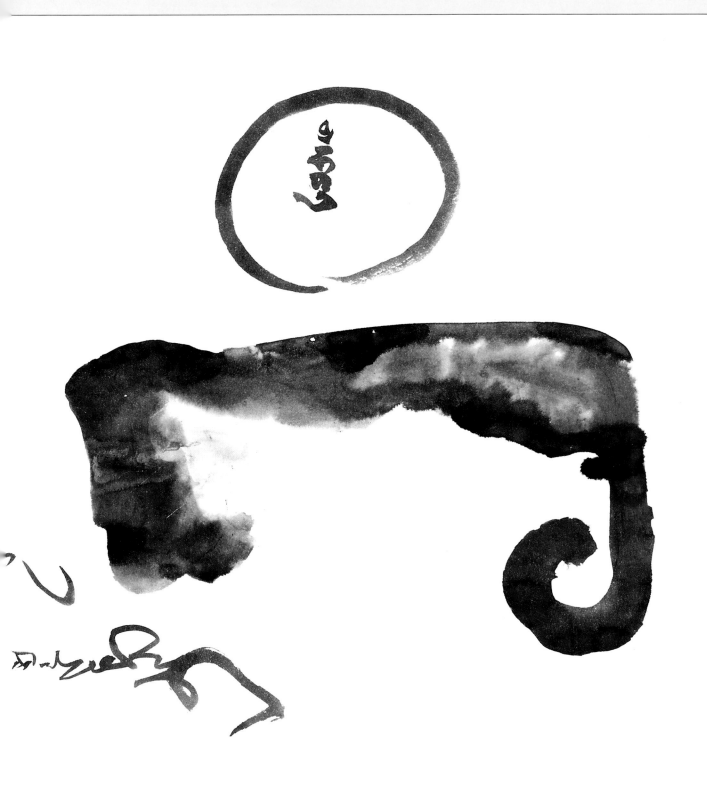

ཧཱུྃ

HUM

"In the boundless space of suchness, ⁂
In the play of the great light, ⁂
All the miracles of sight, sound and mind ⁂
Are the five wisdoms and the five buddhas. ⁂
This is the mandala which is never arranged but is
 always complete." ⁂

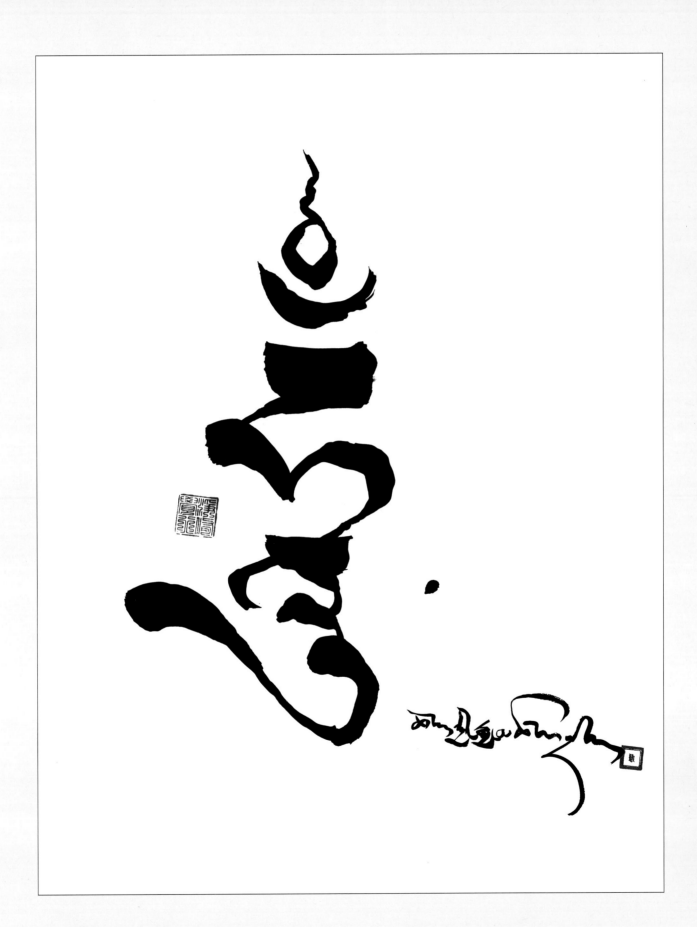

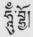

HUM BHYO

"The simultaneous experience of confusion and sanity, or being asleep and awake, is the realization of coemergent wisdom. Any occurrence in one's state of mind—any thought, feeling, or emotion—is both black and white; it is both a statement of confusion and a message of enlightened mind. Confusion is seen so clearly that this clarity itself is sacred outlook."

The two seed syllables HUM and BHYO evoke the union of the masculine and feminine dharma-protection principles.

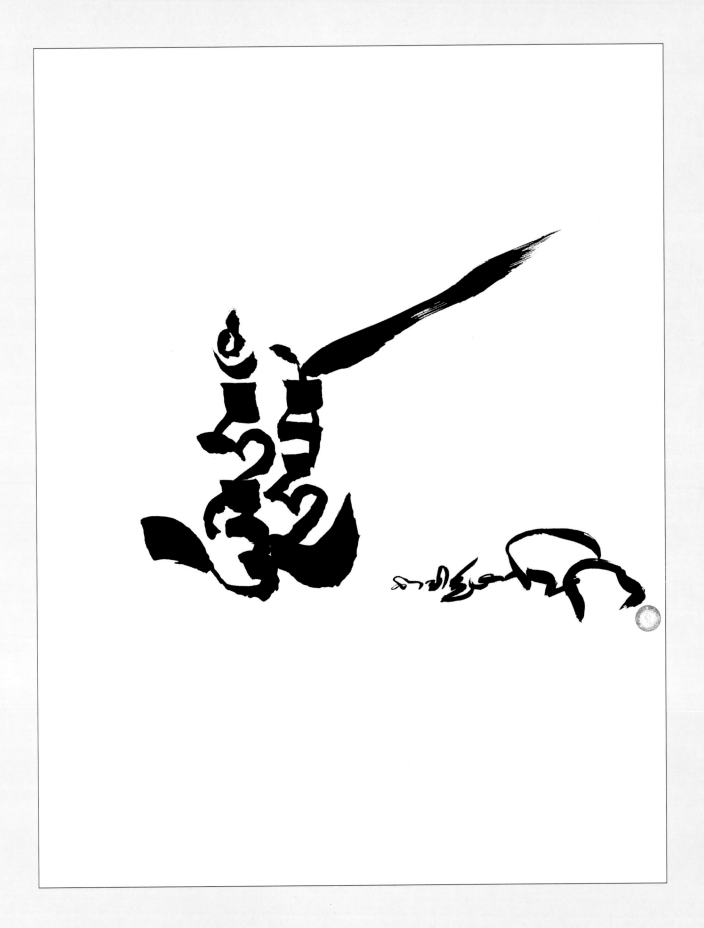

ཝཾ་བྷྱོ།

VAM BHYO

"When we accept uncertainty as the working base, then we begin to discover that we do not exist. We can experience and appreciate the ambiguity as the source of confusion as well as the source of humor."

This calligraphy was probably created with Ekajati in mind (see next calligraphy), as these seed syllables also appear in a liturgy Trungpa Rinpoche composed to her.

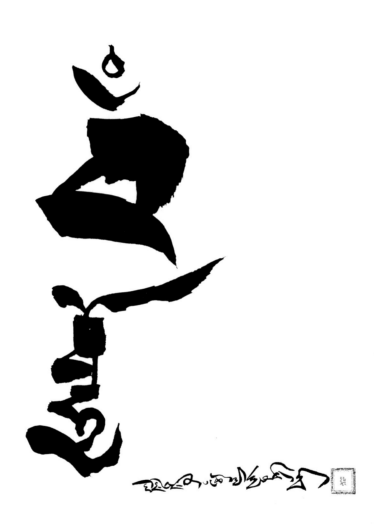

ༀ་མ་མ་རུ་ལུ་རུ་ལུ་ཧཱུྃ་བྷྱོ་ཧཱུྃ༔

OM MAMA RULU RULU HUM BHYO HUM ༔

"She was wearing a tigerskin skirt,
She had a giant smile but one tooth,
She had turquoise hair but elegant gaze
From her single eye."

The mantra of Ekajati, protectress of the seventeen higher tantras.
Trungpa Rinpoche regarded Ekajati to be the protector of the Karmê-
Chöling Meditation Center in particular, and Karmê-Chöling residents
include her liturgy in their daily chants.

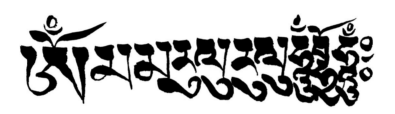

"A crow is black
Because the lotus is white.
Ants run fast
Because the elephant is slow.
Buddha was profound;
Sentient beings are confused."

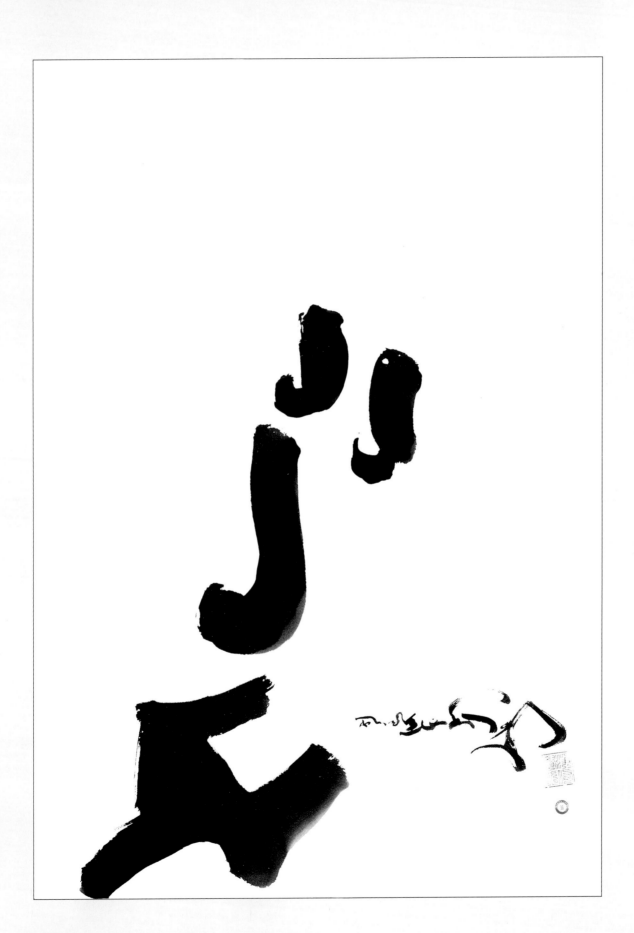

"Since there is already such space and openness and the total absence of fear, the play of the wisdoms is a natural process."

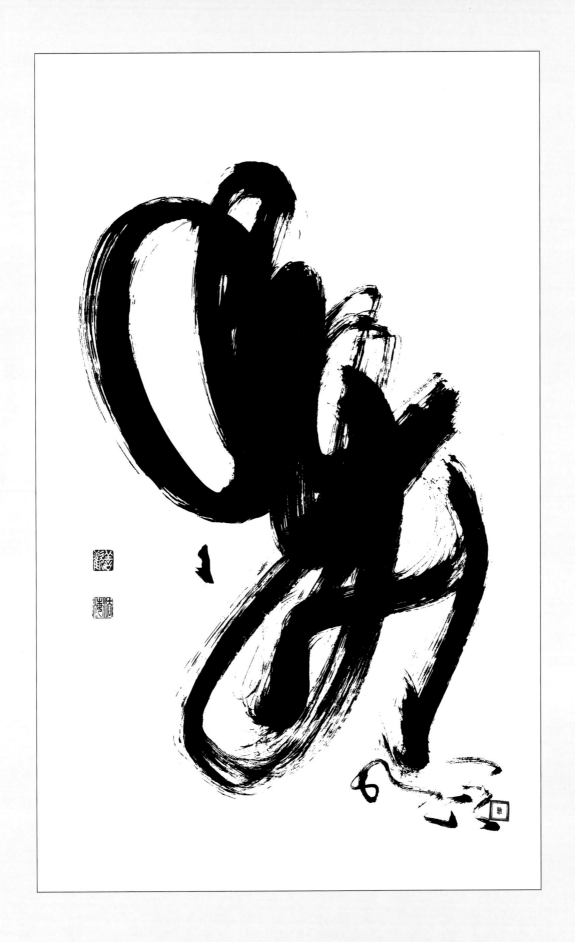

ཆོས་ཉིད་འབུམ་འཕྱུགས་ཀྱི་རྒྱ་མཚོ།

Ocean turbulent with innumerable waves of emptiness

"The source of energy which need not be sought is there; it is that you are rich rather than being enriched by something else. Because there is basic warmth as well as basic space, the Buddha activity of compassion is alive and so all communication is creative."

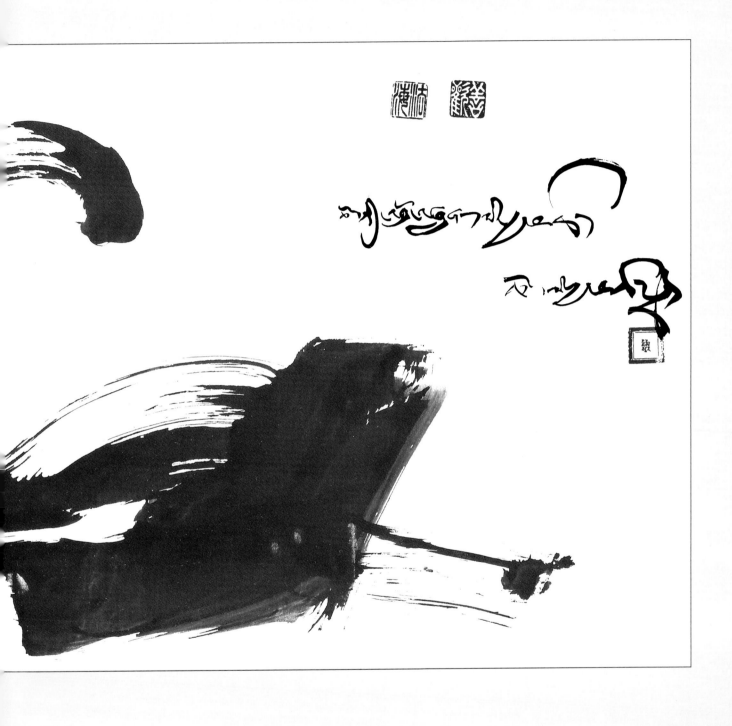

"... confidence does not mean that you have confidence in something, but it is remaining in the state of confidence, free from competition or one-upmanship. This is an unconditional state in which you simply possess an unwavering state of mind that needs no reference point. There is no room for doubt; even the question of doubt does not occur."

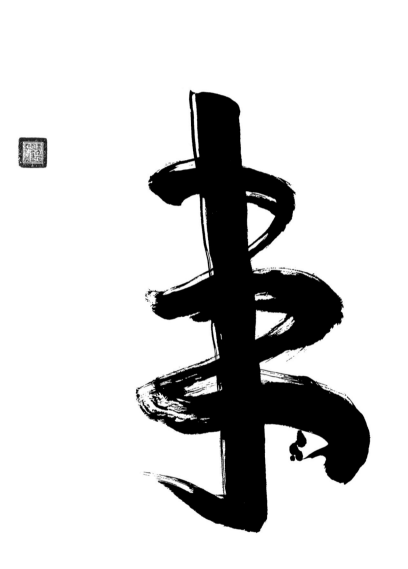

རྒྱལ་ཁྲིམས།

King's law

"When you walk into this world of reality, the greater or cosmic world, you will find the way to rule your world— but, at the same time, you will also find a deep sense of aloneness. It is possible that this world could become a palace or a kingdom to you, but as its king or queen, you will be a monarch with a broken heart."

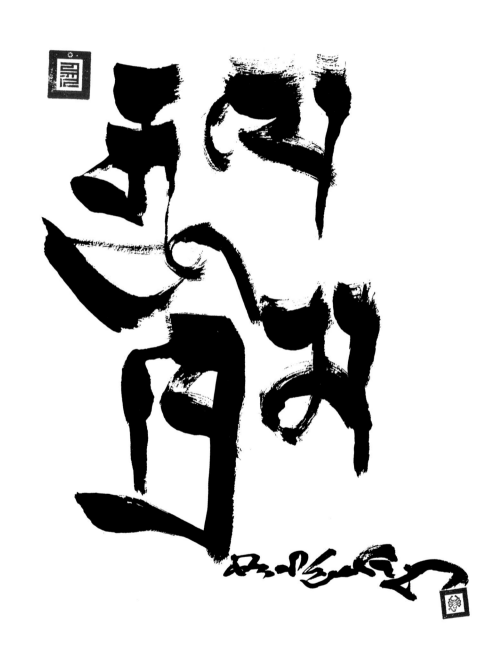

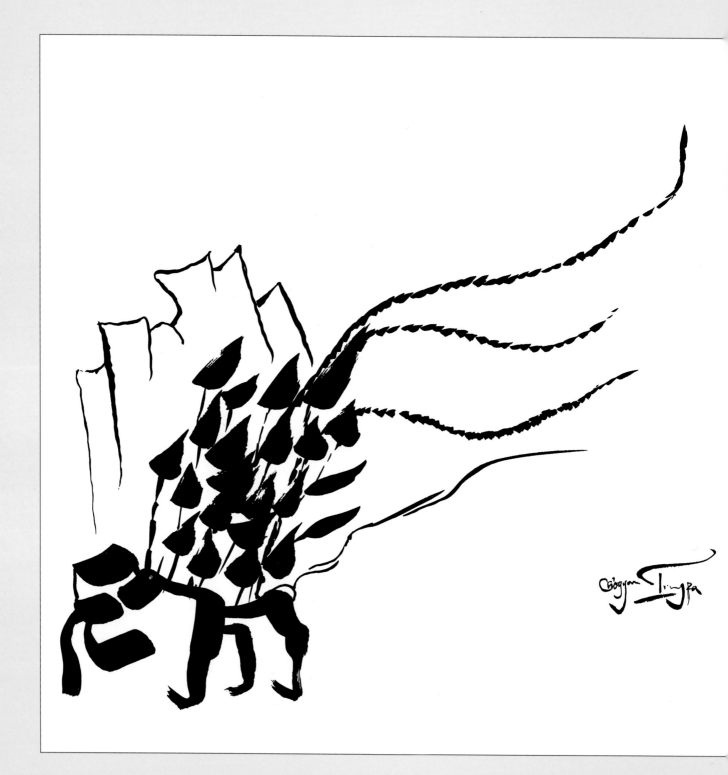

"O pillar of the sky, high mountain peak,
Hills, where trees and grasses grow, surround you,
Yet you remain alone and still,
The cloud of peace wrapped round your shoulders."

ཀླུང་རྟ།

Windhorse

"The wind principle is that the energy of basic goodness is strong and exuberant and brilliant. It can actually radiate tremendous power in your life. But at the same time, basic goodness can be ridden, which is the principle of the horse. By following the disciplines of warriorship, particularly the discipline of letting go, you can harness the wind of goodness."

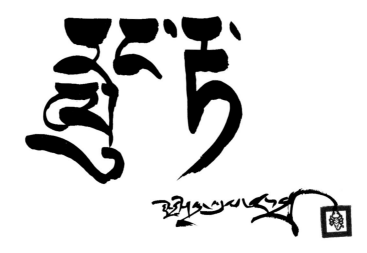

ས་སྐྱོང་།

Earth protector

"One who can actually conquer the earth and sit on the
earth in the fullest and best manner is truly the universal
monarch. . . . The Tibetan word is *sakyong: sa* means
'earth,' *kyong* means 'protector.' The 'protector of the earth'
is one who makes a relationship with earth instead of just
trying to conquer earth by shooting darts and arrows and
bombs at it. So nontheistic royalty comes not so much from
heaven, as from earth."

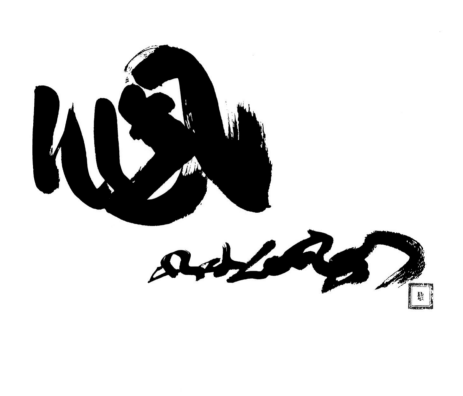

ཉི་མ།

Sun

"The Great Eastern Sun illuminates the way of discipline
for the warrior. An analogy for that is the beams of light
you see when you look at the sunrise. The rays of light
coming towards you almost seem to provide a pathway for
you to walk on. In the same way, the Great Eastern Sun
creates an atmosphere in which you can constantly move
forward, recharging energy all the time."

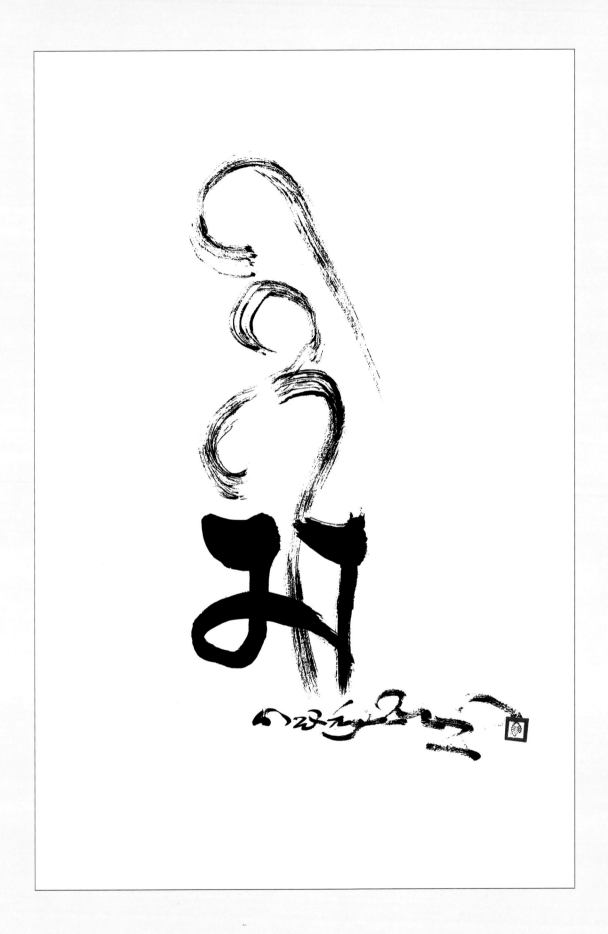

བློ་གྲོས་ཟླ་བ།

Intellect moon

"If you are purely looking for answers, then you don't perceive anything. In the proper use of intellect, you don't look for answers, you just see."

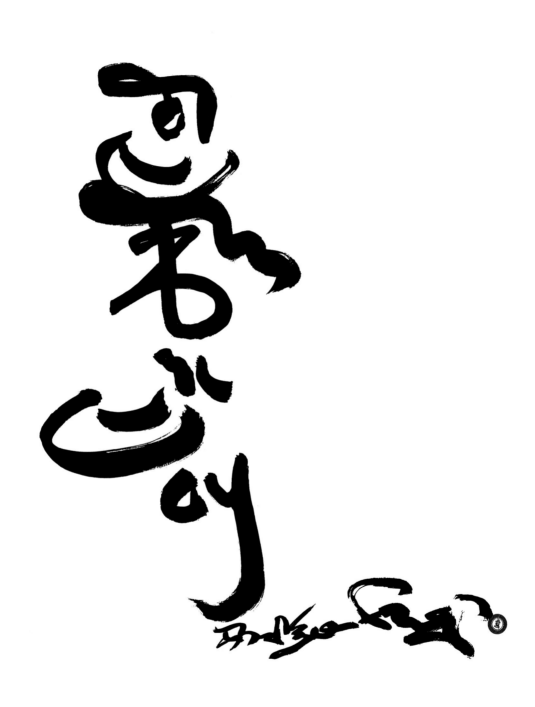

"It is possible to go beyond personal interpretation, to let vastness into our hearts through the medium of perception. We always have a choice: we can limit our perception so that we close off vastness, or we can allow vastness to touch us."

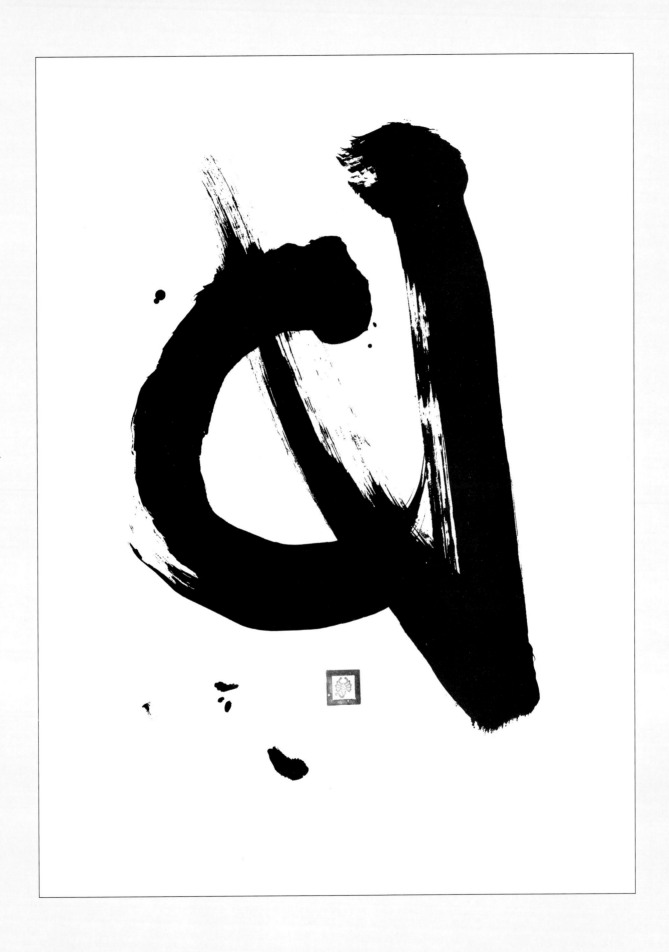

དཔའ་ལྷ།

གནམ་ས་གཅིག་ཏུ་སྦྱེལ་བའི་ཕྱིར།

དོན་གྱི་དཔའ་བོ་མི་འགྱུར་བས།

ཏག་ཏུ་ཁྱོད་ལ་སྐྱོང་གྱུར་ཅིག

ཚེ་རིང་ནད་མེད་དཔལ་དང་ལྡན།

གདོད་མའི་གཟི་བརྗིད་ཀུན་ཏུ་རྒྱས།

དགེ་མཚན་རླུང་རྟ་བཟང་པོ་ཡི།

དབུ་འཕང་རྟག་ཏུ་མཐོ་བར་ཤོག།

Drala ("Beyond aggression")

In order to join heaven and earth,
May the ultimate, unchanging warrior
Always protect you.
May you have long life, freedom from sickness, and glory.
May your primordial confidence always flourish.
May the virtuous mark of excellent windhorse
Always be uplifted.

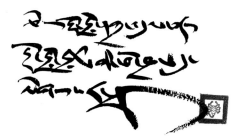

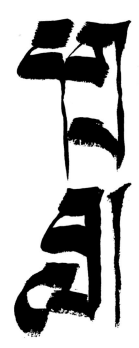

ཚོས།

Dharma

"Taking refuge in the dharma means that the experiences that go through your life, pain and pleasure alike, are all sacred teachings. The teachings are not sacred because they were discovered in space or because they came from the sky and were given by divine principles. But the teachings were discovered in the heart, in human hearts—in buddha nature."

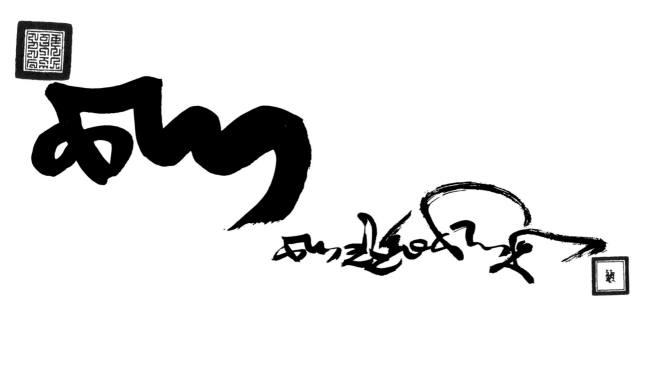

"Tantra is deliberate, but at the same time, the heart of that deliberateness is freedom. . . . The sense of indestructibility is always there. There is intention, there is reality, and there are constant discoveries."

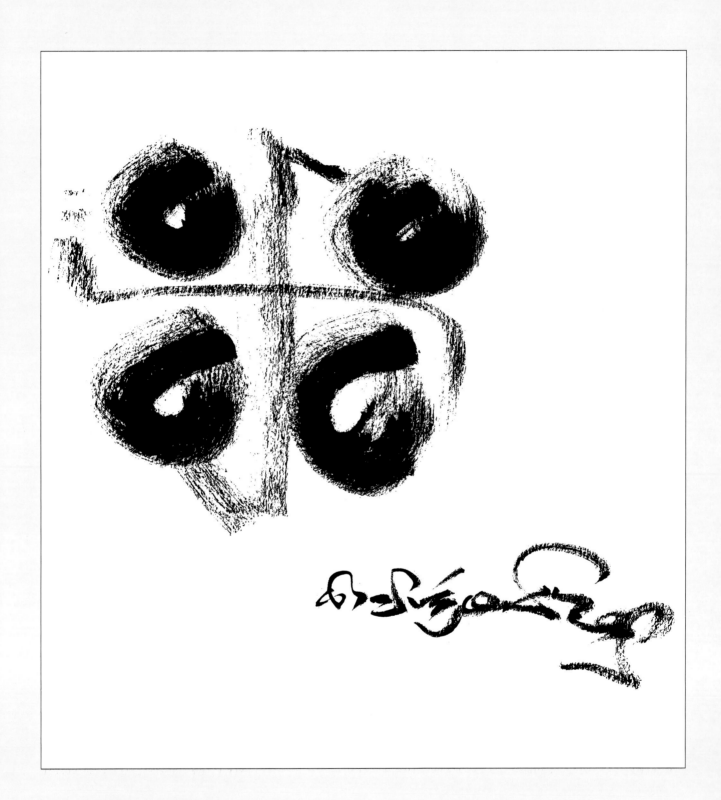

HRIH

"Because things have a self-existing simplicity, they do not need any reference point."

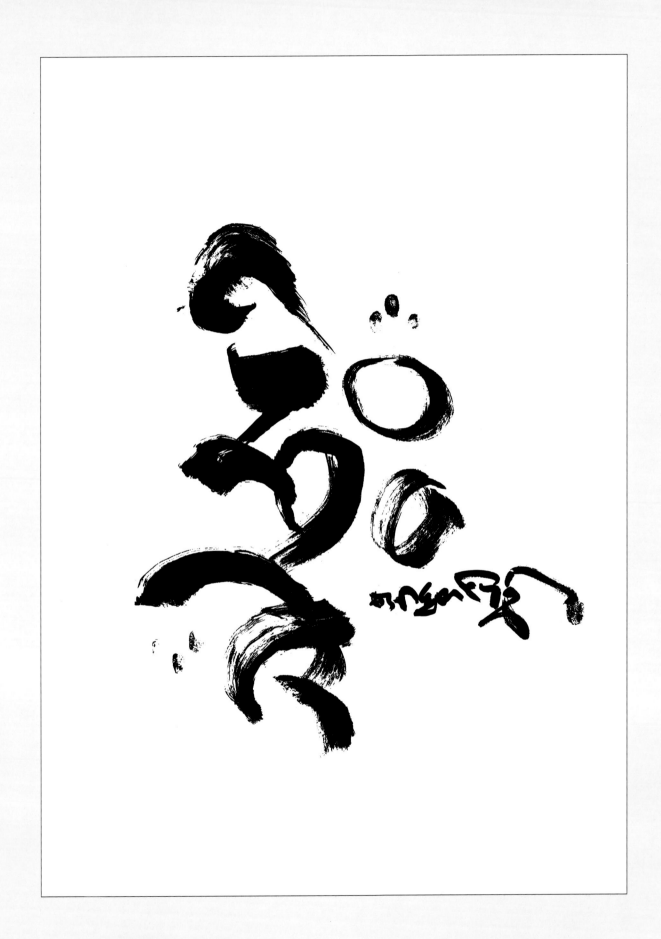

ཤེས་རབ་ཉི་མ་འཆར་བ་དང་།
འོད་གསལ་ཁྱུང་མཚོ་རྒྱས་པའི་ཚེ།
ཤར་ཆེན་ཉི་མ་རྟག་ཏུ་འཕེལ།

When the sun of prajna rises
And luminosity swells like oceans of garudas,
The Great Eastern Sun will always shine.

"Garuda is the mighty force of creation and destruction.
He acts unerringly and will not hesitate.
The children of Shambhala will follow the pattern of his
 swooping and wheeling
And the two opposing forces will come to balance one an-
 other in perfect harmony.
That is the future of mankind."

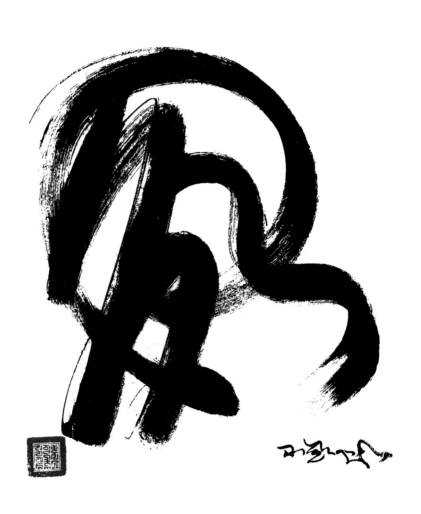

ཉི་མས།

By the sun

"In the vision of the Great Eastern Sun, no human being
is a lost cause. We don't feel that we have to put a lid on
anyone or anything. We are always willing to give things
a chance to flower."

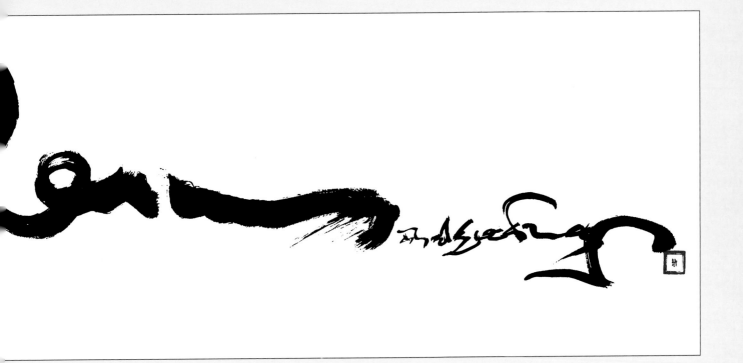

皇

ཀུལ།

Imperial

"In Chinese the character for the ruler, or king, is a vertical
line joining three horizontal lines, which represent heaven,
earth, and man. This means that the king has the power to
join heaven and earth in a good human society."

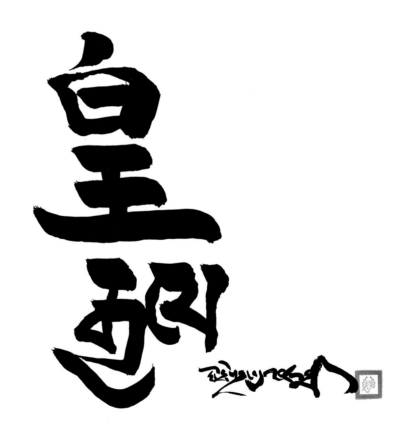

སངས་རྒྱས་སྟོང་གི་དགོངས་པ་མ་རྫོགས་བར། །

འགྲོ་འདྲེན་ཀརྨ་པའི་བསྟན་པ་ནུབ་མི་སྲིད། །

Until the intentions of a thousand buddhas are complete,
The teachings of the Karmapa, the guide of beings, will
 never set.

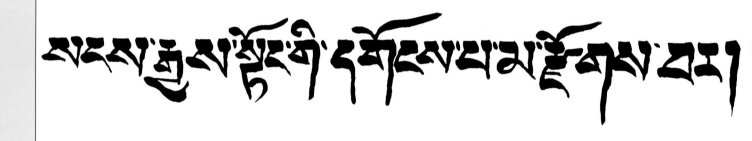

འགྲོ་འཕྲེན་གཅེའི་བསྐུར་པ་ཆུ་མི་སྲིད།

གནམ་ས་མི།

Heaven, earth, and man

"Heaven is the source of the rain that falls on the earth, so heaven has a sympathetic connection with earth. When that connection is made, then the earth begins to yield. It becomes gentle and soft and pliable, so that greenery can grow on it, and man can cultivate it."

વહુની
પા
ળ

રઘુવીરચૌધરી

ཀླུང་རྟ།

Windhorse

"When you live your life in accordance with basic goodness,
then you develop natural elegance. Your life can be spacious
and relaxed, without having to be sloppy. You can actually
let go of your depression and embarrassment about being
a human being, and you can cheer up. You don't have to
blame the world for your problems. You can relax and appre-
ciate the world."

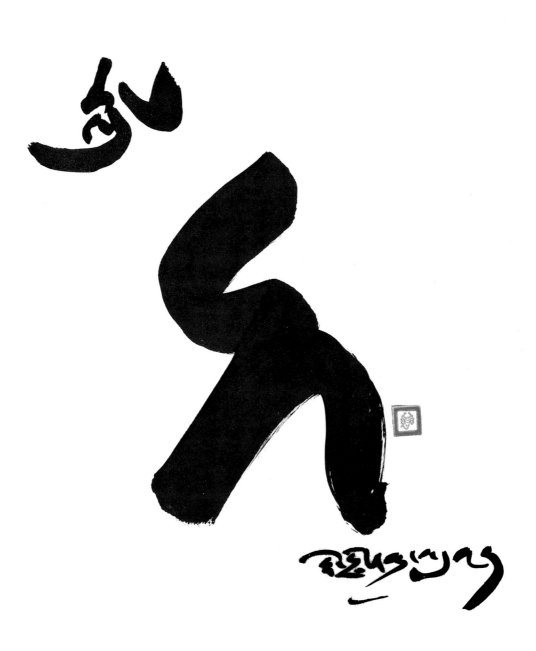

ह

JAM

"The key to wealth, or the golden key, is appreciating that
you can be poor—or I should say, unmoneyed—and still
feel good, because you have a sense of wealthiness in any
case, already. That is the wonderful key to richness and the
first step in ruling: appreciating that wealth and richness
come from being a basically decent human being. You do not
have to be jealous of those who have more, in an economic
sense, than you do. You can be rich even if you are poor."

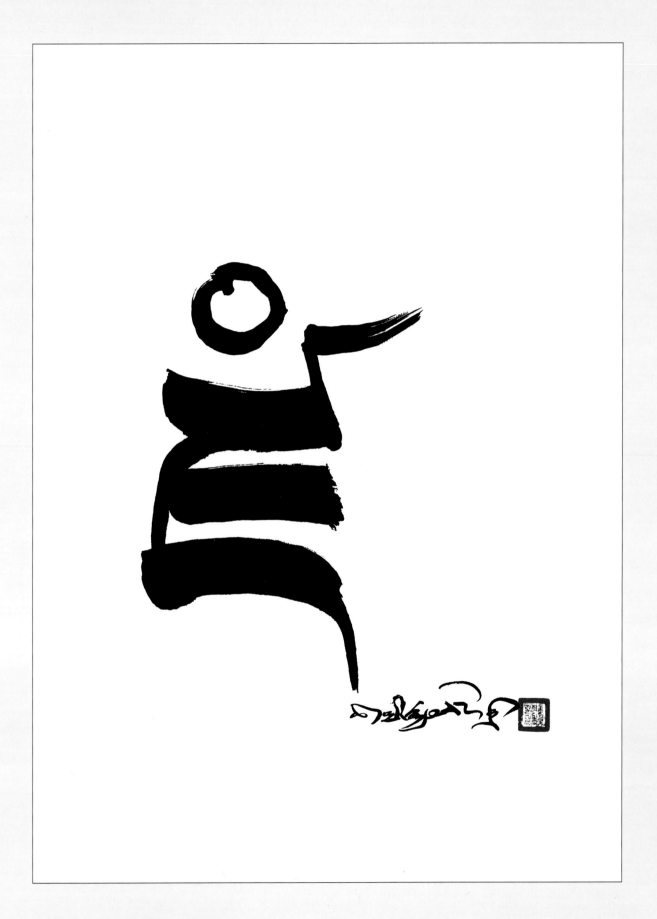

སྟག་སེང་ཁྱུང་འབྲུག

Tiger lion garuda dragon

"The tiger has developed more stripes.
The lion has developed more mane.
Could the garuda fly further!
Is it possible that the dragon could resound deeper!
Could my ten years of being here be more!
Sometimes I feel I have been in North America 10,000 years;
Other times, maybe only ten seconds—
We grow young and old simultaneously."

ཀི་ཀི་བསོ་བསོ།

Ki ki so so

"All goes well.
Ki Ki—all goes worthywhile—so so!
I take pride in our expedition.
Since my mother left me without her fur chuba
I decided always to be chubaless,
A warrior without wearing clothes, walking in the cold."

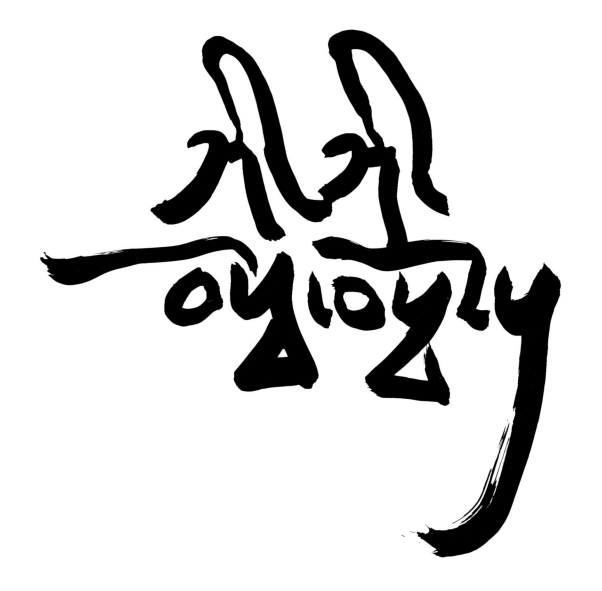

གཟི་བརྗིད།

Confidence (Dignity)

"Unconditional confidence contains gentleness, because the notion of fear does not arise; sturdiness, because in the state of confidence there is ever-present resourcefulness; and joy, because trusting in the heart brings a greater sense of humor. This confidence can manifest as majesty, elegance, and richness in a person's life."

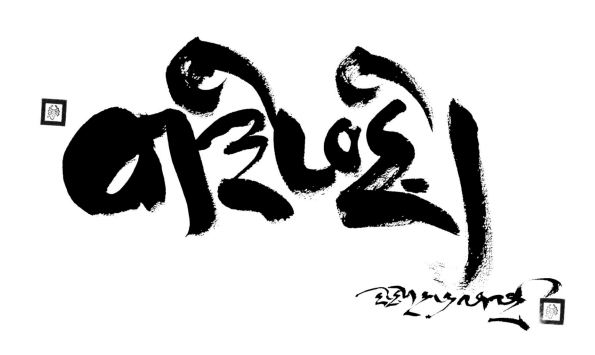

ཕར་ཆེན་ཉི་མ།

Great Eastern Sun

"Awakened heart comes from being willing to face your
state of mind. That may seem like a great demand, but it is
necessary. You should examine yourself and ask how many
times you have tried to connect with your heart, fully and
truly. . . . That is the sixty-four-thousand-dollar question:
how much have you connected with yourself at all in your
whole life?"

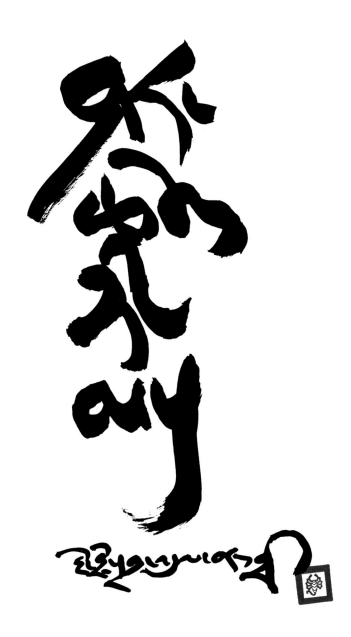

རྡོ་རྗེ་དབྱིངས་ཀ་ན་ཌ།

Vajradhatu Canada

"From space without beginning or end,
The fire without center or fringe blazes.
The splendor of wisdom radiates beauty.
At this moment, Vajradhatu dawns."

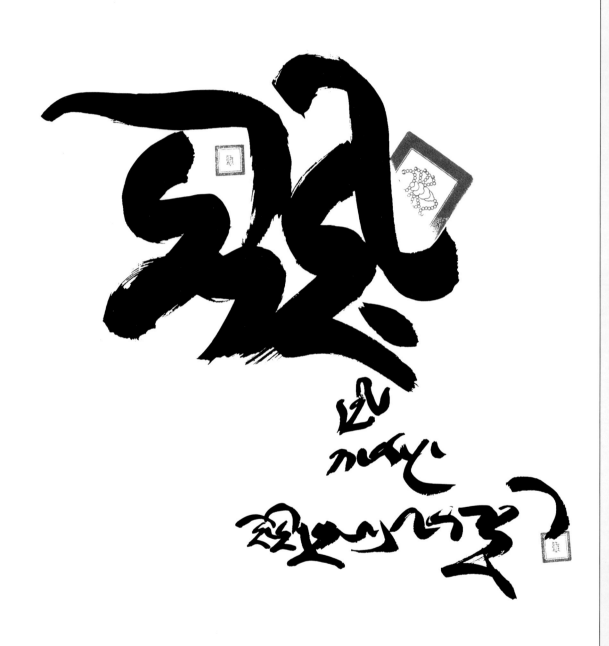

གནམ་ས་འབྲེལ།

Joining heaven and earth

"The master warrior, out of his great compassion for human beings, is able to join heaven and earth. That is to say, the ideals of human beings and the ground where human beings stand can be joined together by the power of the master warrior. Then heaven and earth begin to dance with each other, and human beings feel that there is no quarrel about who possesses the best part of heaven or the worst part of earth."

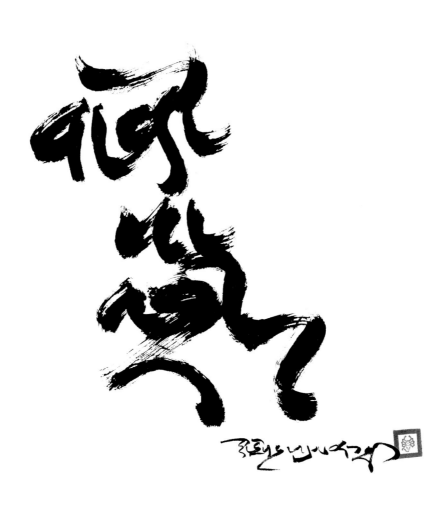

"Crazy wisdom is absolute perceptiveness, with fearlessness and bluntness. Fundamentally, it is being wise, but not holding to particular doctrines or disciplines or formats. There aren't any books to follow. Rather, there is endless spontaneity taking place."

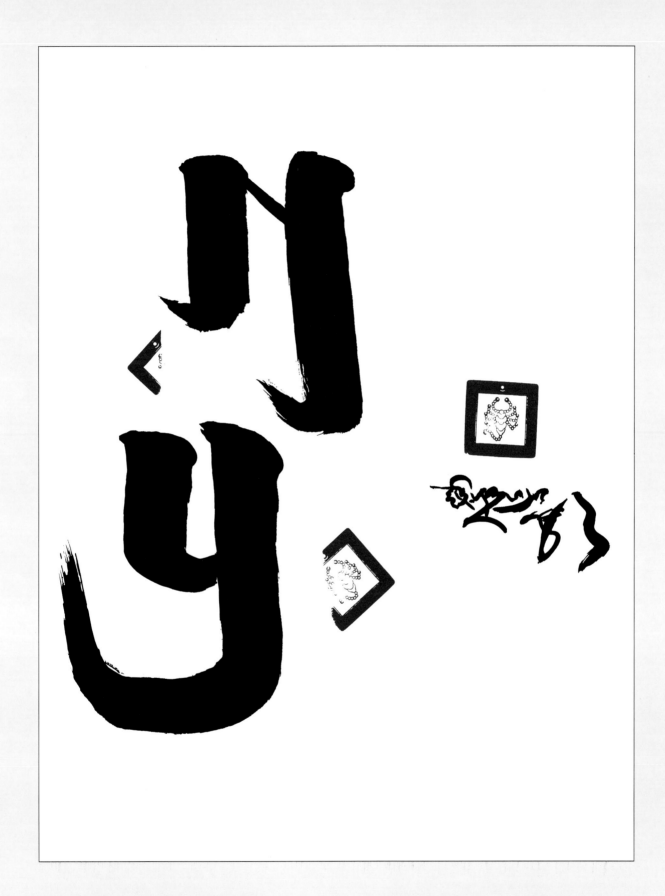

"Nowness, or the magic of the present moment, is what joins the wisdom of the past with the present. When you appreciate a painting or a piece of music or a work of literature, no matter when it was created, you appreciate it now. You experience the same nowness in which it was created. It is always now."

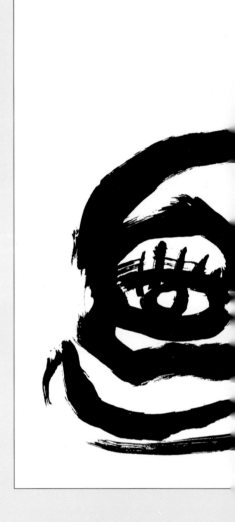

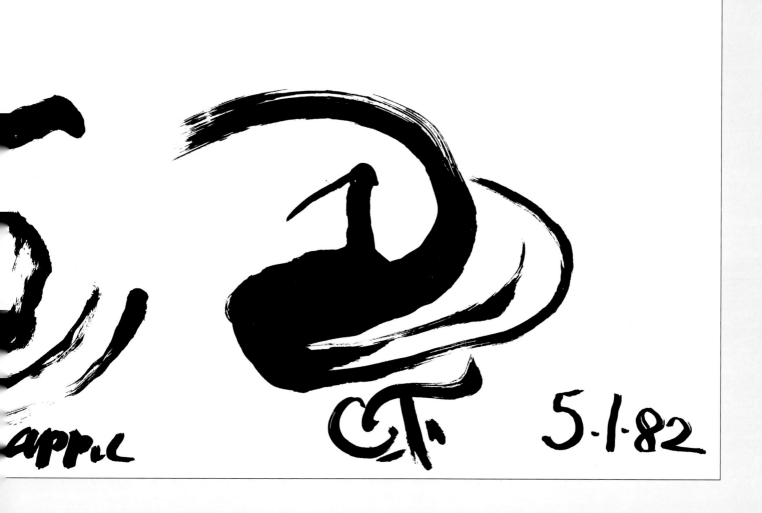

april 5·1·82

བདེ་བའི་ལང་ཚོ།

Blissful youth

"The child's world has no beginning or end.
To him, colors are neither beautiful or ugly.
The child's nature has no preconceived notion of birth
 and death.
The golden mountain is solid and unchanging,
The ruby sun is all-pervading,
The crystal moon watches over millions of stars.
The child exists without preconceptions."

ཕར་ཆེན་ཉི་མ།

Great Eastern Sun

"The ideal of warriorship is that the warrior should be sad
and tender, and because of that, the warrior can be very
brave as well. Without that heartfelt sadness, bravery is
brittle, like a china cup. If you drop it, it will break or chip.
But the bravery of the warrior is like a lacquer cup, which
has a wooden base covered with layers of lacquer. If the cup
drops it will bounce rather than break. It is soft and hard at
the same time."

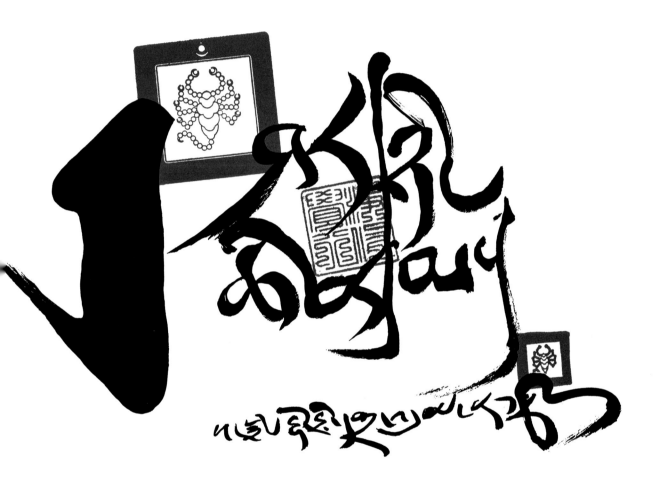

སྨུག་པོ།

Mukpo

"In whatever he does, the master warrior of Shambhala guides the minds of his students into the visionary mind of the Rigden kings, the space of the cosmic mirror. He constantly challenges his students to step beyond themselves, to step out into the vast and brilliant world of reality in which he abides."

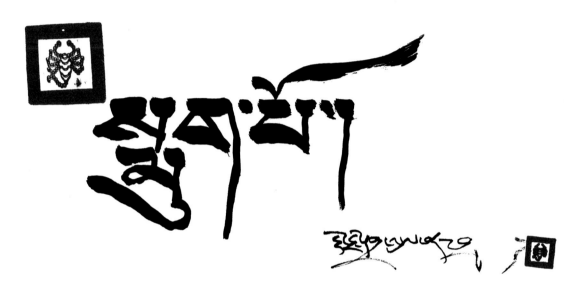

སྐྱེ་བ་ཀུན་ཏུ་ཡང་དག་བླ་མ་དང་།
འབྲལ་མེད་ཆོས་ཀྱི་དཔལ་ལ་ལོངས་སྤྱོད་ཅིང་།
ས་དང་ལམ་གྱི་ཡོན་ཏན་རབ་རྫོགས་ནས།
རྡོ་རྗེ་འཆང་གི་གོ་འཕང་མྱུར་ཐོབ་ཤོག།

Through all my births may I not be separated from the
 perfect guru
And so enjoy the splendor of dharma.
Perfecting the virtues of the paths and bhumis,
May I speedily attain the state of Vajradhara.

A traditional verse of aspiration.

ཕོག་མ་ཐ་མ་མི་དམིགས།

སྟག་སེང་ཁྱུང་འབྲུག་དཔལ་དང་ལྡན།

བརྗོད་ལས་འདས་པའི་གཟི་བརྗིད་ཅན།

རིག་ལྡན་རྒྱལ་པོའི་ཞབས་ལ་འདུད།།

神　དབ་ཟླ།

He who has neither beginning nor end,
Who possesses the glory of Tiger Lion Garuda Dragon,
Who possesses the confidence beyond words:
I pay homage at the feet of the Rigden king.

Kami/Drala

158

Appendix: About the Seals

The seals of the Trungpa tülkus embody the religious and political interaction between Tibet, China, Mongolia, and even Nepal. Besides having a different origin, each seal evokes a different image or energy. For example, when Chögyam Trungpa Rinpoche—the eleventh Trungpa tülku—executed a calligraphy, he would have all of his seals brought along for his use. Depending on whether the theme of the calligraphy was more "Buddhist" or more "Shambhalian," that is, more religious or more secular, he would use a different seal. Out of his nine known seals, seven are represented in this book.

The oldest seal pictured in this book is the official seal of the Trungpa tülkus, a beautifully carved ivory seal with a wheel-of-dharma handle. It was given by the Chinese emperor to the fifth Trungpa, Tendzin Chögyal, sometime in the seventeenth or eighteenth century. Written in Chinese seal script are the characters *ching yu chueh wang,* meaning "pure attendant, enlightened king." Actually, the meaning of the first two characters is uncertain, but they could be a play on the literal meaning of *trungpa,* namely "attendant."

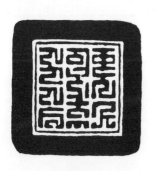

The seal identified in the notes as "a seal of the Trungpa tülkus" was evidently given to a previous Trungpa tülku by one of the Dalai Lamas. It is a wooden teak seal with a round, knobby handle seemingly carved in the shape of a peony (a symbol of royalty). The seal characters are written in Tibetan seal script and read *svasti, gushri, chel-o* [?]. The first word is a Sanskrit word, meaning literally "it is good," and is generally used as a declaration of auspiciousness. The second word is the Tibetan phoneticization of the same Chinese word *kuo shih,* "imperial teacher." The last word is still undeciphered; it might refer to a place name.

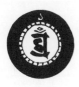

The "evam seal" is a small, round ivory seal. This is another official seal for the Trungpa tülkus, and it has the Trungpa tülku logo, an artistic representation of the Sanskrit word *evam. Evam* literally means "thus" and appears at the beginning of all Buddhist sutras in the phrase *evam maya shrutam,* which means "thus have I heard." In another context, *e* represents the passive, feminine, empty aspect of reality, and *vam* the active, masculine, luminous aspect. Chögyam Trungpa Rinpoche had this seal made in Taiwan while he was at Oxford University

in England, as the one he used to have in Tibet was lost. In Tibet, he sometimes used it as a name label, and sealed the bottom edge of brocade dancing costumes that were being lent out.

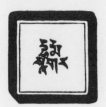

The "Dharmasara seal" is also made of ivory, and was also made while Trungpa Rinpoche was at Oxford. This is a personal seal, as it has Dharmasa(ga)ra, the Sanskrit equivalent of Trungpa Rinpoche's personal name, Chökyi Gyatso, engraved in Tibetan letters. It was made in Thailand, where unfortunately a syllable of the Sanskrit was omitted. This was later corrected in a newer ivory seal.

The two seals called "name seals" in the notes were cut out of stone for Trungpa Rinpoche in the 1970s, possibly in California. (See page 91 for examples.) The red-on-white seal says in Chinese seal script *fa hai*, "Dharma Ocean," whereas the white-on-red one says *shan huan*, "Goodness Joy." Trungpa Rinpoche's full *shramanera* (novice monk) name is Karma Ngawang Chökyi Gyatso Künga Zangpo, so when he put these two seals next to each other, he was signing his work Chökyi Gyatso Künga Zangpo, "Ocean of Dharma All-Joyful Goodness," or in the Chinese—"Dharma Ocean Goodness Joy."

Also shown in this book are two seals known as the "scorpion seals"—one large, one small. They have the design of a scorpion, a design previously used for the seal of the King of Dege (a kingdom in Eastern Tibet). For Trungpa Rinpoche, they are seals of the Mukpo family or clan. These "scorpion seals" signify the power of command. If one rejects the command, one gets stung. In the border at the top of the seal is a small crescent moon and sun, which represent the unity of masculine and feminine principles.

Adapted from John Rockwell, Jr., "The Labyrinth of Tibetan Seals," in the *Vajradhatu Sun*, June/July 1985. Used by arrangement with the author. The impressions of the seals shown here were made by Trungpa Rinpoche's eldest son, the Sawang Ösel Rangdröl Mukpo.

Notes

<div style="display:flex">

<div>

Front endpaper
1980, Boulder, Colorado
Ink on gold paper, 37 × 72 in. (94 × 183 cm.)
Signed: Dorje Dradül
Large scorpion seal
Birthday card
Collection of David I. Rome

Facing p. 52
No date, Karmê-Chöling
Ink on paper, 30 × 20 in. (76 × 51 cm.)
Signed: Chökyi Gyatso
Evam seal
Collection of Karmê-Chöling

Facing pp. 54–60
1971, Boulder, Colorado
Ink on paper, 24 × 19 in. (61 × 48 cm.)
 24 × 19 in. (61 × 48 cm.)
 24 × 19 in. (61 × 48 cm.)
 24 × 19 in. (61 × 48 cm.)
Signed: Chökyi Gyatso
No seal
Collection of Polly Wellenbach

Facing p. 62
No date
Ink on paper, 26 × 36 in. (66 × 91 cm.)
Signed: Chökyi Gyatso
Evam seal
Collection of Karmê-Chöling

Facing p. 64
No date, Karmê-Chöling
Ink on paper, 30 × 20 in. (76 × 51 cm.)
Signed: Chögyam
No seal
Collection of Karmê-Chöling

Facing p. 66
1971
Ink on paper, 15 × 13 in. (38 × 33 cm.)
Signed: CT
No seal
Collection of Michael and Joanne Fagan

</div>

<div>

Facing p. 68
1973, Jackson Hole, Wyoming
Ink on textured paper, 18 × 12 in. (46 × 30 cm.)
Signed: Chögyam
No seal
Wedding gift
Collection of Mipham and Abbie Halpern

Facing p. 70
1973, Jackson Hole, Wyoming
Ink on paper, 16 × 12 in. (41 × 30 cm.)
Signed: Chögyam
No seal
Wedding gift
Collection of Mipham and Abbie Halpern

Facing p. 72
1973, Jackson Hole, Wyoming
Ink on paper, 18 × 12 in. (46 × 30 cm.)
Signed: Chögyam
No seal
Wedding gift
Collection of Mipham and Abbie Halpern

Facing p. 74
1974
Ink on paper, 84 × 15 in. (213 × 38 cm.)
 47 × 15 in. (119 × 38 cm.)
 33 × 15 in. (84 × 15 cm.)
Signed: Chökyi Gyatso
Dharmasara seals
Shown at art exhibit, New York, 1974
Collection of Brad and Mindy Upton

Facing p. 76
1975
Ink on paper, 22 × 30 in. (56 × 76 cm.)
Signed: Chökyi Gyatso
Dharmasara seal
Wedding gift
Collection of Mr. and Mrs. John Roper

</div>

</div>

Facing p. 78
1974, Boulder, Colorado
Ink on paper, 18 × 22 in. (46 × 56 cm.)
Signed: Chökyi Gyatso
No seal
Created for the opening of Diana J. Mukpo's antique store
Collection of Mrs. Julie Novick

Facing p. 80
No date
Ink on paper, 27 × 34 in. (69 × 86 cm.)
Signed: Chökyi Gyatso
Upper left: official Trungpa seal
Lower right: Dharmasara seal
Private collection

Facing p. 82
No date
Ink on paper, 29 × 23 in. (74 × 58 cm.)
Signed: Chökyi Gyatso
Evam seal
Collection of New York Dharmadhatu

Facing p. 84
No date, Karmê-Chöling
Ink on paper, 20 × 30 in. (51 × 76 cm.)
Signed: Dorje Dzinpa Chökyi Gyatso
Dharmasara seal
Collection of Karmê-Chöling

Facing p. 86
No date, Karmê-Chöling
Ink on paper, 20 × 30 in. (51 × 76 cm.)
Signed: Dorje Dzinpa Chökyi Gyatso
Evam seal
Collection of Karmê-Chöling

Facing p. 88
No date
Ink on shikishi board, 42 × 30 in. (107 × 76 cm.)
Signed: Chökyi Gyatso
Upper: official Trungpa seal
Lower: evam seal
Collection of Vajradhatu

Facing p. 90
1977, Charlemont, Massachusetts
Ink on paper, 36 × 24 in. (91 × 61 cm.)
Signed: Chögyam
Upper left: name seals

Lower right: Dharmasara seal
Private collection

Facing p. 92
No date
Ink on paper, 17 × 23 in. (43 × 58 cm.)
Signed: Chökyi Gyatso
Upper right: name seals
Lower right: Dharmasara seal
Collection of Eric Shaffer

Facing p. 94
1977, Charlemont, Massachusetts
Ink on paper, 42 × 30 in. (107 × 76 cm.)
Signed: Dorje Dradül
Upper left: a seal of the Trungpa tülkus
Lower right: name seals
Collection of Gina Stick

Facing p. 96
1978
Ink on paper, 30 × 22 in. (76 × 56 cm.)
Signed: Chökyi Gyatso
Small scorpion seal with seal of the Vajra Regent Ösel
 Tendzin
Gift to John Roper, legal counsel of Vajradhatu
Collection of John Roper

Page 98
No date
Ink on paper, 17 × 23 in. (43 × 58 cm.)
Signed: Chögyam Trungpa
No seal
Birthday gift for Jane Condon Grimes
Collection of Jane Condon Grimes and Brian W. Grimes

Facing p. 100
1978
Ink on paper, 20 × 26 in. (50 × 66 cm.)
Signed: Dorje Dradül
Small scorpion seal
Collection of Philip and Karen Weber

Facing p. 102
1978
Ink on paper, 22 × 30 in. (56 × 76 cm.)
Signed: Chökyi Gyatso
Dharmasara seal
Wedding gift
Collection of the Drescher family

Facing p. 104
1979, Boulder, Colorado
Ink on paper, 36 × 24 in. (91 × 61 cm.)
Signed: Chökyi Gyatso
Small scorpion seal
Given to Polly Wellenbach when she was appointed director
 of Karma Dzong, Boulder
Collection of Polly Wellenbach

Facing p. 106
No date, Karmê-Chöling
Ink on paper, 23 × 29 in. (58 × 74 cm.)
Signed: Chökyi Gyatso
Evam seal
Collection of Karmê-Chöling

Facing p. 108
1979, Boulder, Colorado
Ink on paper, 24 × 18 in. (61 × 46 cm.)
Unsigned
Small scorpion seal
Created during a total solar eclipse
Collection of Jeremy Hayward

Facing p. 110
1979, Boulder, Colorado
Ink on paper, 30 × 22 in. (76 × 56 cm.)
Signed: Properly written at the palace of Dorje Dzong by the
 Dorje Dradül
Large and small scorpion seals
Birthday present
Collection of Jeremy Hayward

Facing p. 112
1979, Boulder, Colorado
Ink on paper, 15 × 19 in. (38 × 48 cm.)
Signed: Chökyi Gyatso
Upper left: a seal of the Trungpa tülkus
Lower right: Dharmasara seal
Created as a design for oryoki cloths (cleaning cloths used in
 formal monastic dining)
Collection of Mipham and Abbie Halpern

Facing p. 114
No date, Rocky Mountain Dharma Center
Ink on paper, 18 × 19 in. (45 × 48 cm.)
Signed: Chökyi Gyatso
No seal
Collection of Rocky Mountain Dharma Center

Facing p. 116
1979
Ink on paper, 21 × 29 in. (54 × 75 cm.)
Signed: Chökyi Gyatso
Sealed with fingerprints
Collection of Rocky Mountain Dharma Center

Facing p. 118
1980, Lake Louise, Alberta
Ink on tablecloth, 48 × 54 in. (122 × 137 cm.)
Signed: Dorje Dradül
Many full and partial small and large scorpion seals
An anniversary gift spontaneously created on a tablecloth,
 the poem incorporates the couple's refuge names, Sun of
 Wisdom and Luminosity Garuda Ocean.
Collection of Charles and Judith Lief

Facing p. 120
No date
Ink on paper, 30 × 22 in. (76 × 56 cm.)
Signed: Chögyam
A seal of the Trungpa tülkus
Collection of Neal and Karen Greenberg

Facing p. 122
1980
Ink on paper, 14 × 40 in. (36 × 102 cm.)
Signed: Chökyi Gyatso
Dharmasara seal
Wedding gift
Collection of Hugo Brooks

Facing p. 124
1980, Boulder, Colorado
Ink on paper, 29 × 23 in. (74 × 59 cm.)
Signed: Dorje Dradül
Small scorpion seal
Collection of James and Sharon Hoagland

Facing p. 126
1980, Boulder, Colorado
Ink on acetate, 24 × 72 in. (61 × 183 cm.)
No signature
No seal
Designed as the official welcoming banner for the 1980
 North American visit of His Holiness the Gyalwang
 Karmapa XVI, head of the Kagyü lineage of Tibetan
 Buddhism
Collection of Paul Hannon

Facing p. 128
1980
Ink on paper, 26 × 20 in. (66 × 20 cm.)
Signed: Dorje Dradül
Small scorpion seal
Collection of David and Dinah Brown

Facing p. 130
1980, Boulder, Colorado
Ink on paper, 29 × 23 in. (74 × 58 cm.)
Signed: Dorje Dradül
Small scorpion seal
Created for the Paris Dharmadhatu
Collection of Andy and Wendy Karr

Facing p. 132
No date
Ink on paper, 15 × 11 in. (38 × 28 cm.)
Signed: Chökyi Gyatso
A seal of the Trungpa tülkus
Collection of Vajradhatu

Facing p. 134
1980, Boulder, Colorado
Ink on acetate, 24 × 36 in. (61 × 91 cm.)
No signature
No seal
Collection of Paul Hannon

Facing p. 136
1980, Boulder, Colorado
Ink on acetate, 42 × 36 in. (107 × 91 cm.)
No signature
No seal
Collection of Paul Hannon

Facing p. 138
1981, Boulder, Colorado
Ink on paper, 21 × 30 in. (53 × 76 cm.)
Signed: Dorje Dradül
Small scorpion seals
Collection of Shambhala Publications, Inc.

Facing p. 140
1981, Lake Louise, Alberta
Ink on paper, 23 × 15 in. (59 × 37 cm.)
Signed: Dorje Dradül
Small scorpion seal
Collection of Dan and Meera Meade

Facing p. 142
No date
Ink on paper, 26 × 20 in. (66 × 51 cm.)
Signed: Dorje Dradül
Dharmasara seals and partial large scorpion seal
Collection of Vajradhatu

Facing p. 144
1981, Boulder, Colorado
Ink on paper, 30 × 22 in. (76 × 56 cm.)
Signed: Dorje Dradül
Small scorpion seal
Created for Mayul Farm, Johnson City, Kansas
Collection of John and Emily Sell

Facing p. 146
No date
Ink on paper, 27 × 22 in. (69 × 56 cm.)
Signed: Dorje Dradül
Full and partial scorpion seals
Collection of New York Dharmadhatu

Facing p. 148
1982, Boulder, Colorado
Ink on paper, 30 × 58 in. (76 × 147 cm.)
Signed: C.T.
No seal
One of a series of collaborations among Trungpa Rinpoche,
 Karel Appel, Allen Ginsberg, and José Arguelles, prior to
 the Jack Kerouac Conference at The Naropa Institute.
Collection of The Naropa Institute

Facing p. 150
1984, Philadelphia, Pennsylvania
Ink on paper, 19 × 35 in. (48 × 89 cm.)
Signed: Chökyi Gyatso
Dharmasara seal
Collection of Philadelphia Dharmadhatu

Facing p. 152
No date
Ink on paper, 14 × 17 in. (36 × 43 cm.)
Signed: Sakyong Dorje Dradül
Large and small scorpion seals and the official Trungpa seal
A gift to Kanjuro Shibata Sensei, who in turn gave it to
 Mark Nowakowski
Collection of Mark and Rebecca Nowakowski

Facing p. 154
1983, Karmê-Chöling
Ink on paper, 21 × 29 in. (54 × 75 cm.)
Signed: Dorje Dradül
Large and small scorpion seals
Wedding gift
Collection of Neal and Karen Greenberg

Facing p. 156
No date
Ink on paper, 30 × 20 in. (76 × 51 cm.)
Signed: Chögyam
Dharmasara seal
Collection of Karmê-Chöling

Facing p. 158
1983, Halifax, Nova Scotia
Ink on paper, 36 × 13 in. (91 × 33 cm.)
Signed: Dorje Dradül
Large and small scorpion seals
Collection of the Drescher family

Back endpaper
1983, Boulder, Colorado
Ink on gold paper, 31 × 40 in. (79 × 102 cm.)
Signed: Dorje Dradül
Large and small scorpion seals
Collection of Michael A. Root

Sources

Page 62: Training the Mind and Cultivating Loving Kindness (Boston: Shambhala Publications, 1993), page 200; *64:* from "A Flower Is Always Happy," in *First Thought Best Thought* (Boulder: Shambhala Publications, 1983), page 44; *66:* from "Early Outward," in *Mudra* (Berkeley: Shambhala Publications, 1972), page 54; *68:* from "Burdensome," in *First Thought Last Thought*, page 68; *70:* from "The Silent Song of Loneliness," in *Mudra*, page 34; *72: The Heart of the Buddha* (Boston: Shambhala Publications, 1991), pages 91, 93, 98, 102; *76: Cutting Through Spiritual Materialism* (Boston: Shambhala Publications, 1973), page 218; *80:* from *The Sadhana of Mahamudra* (Halifax, N.S.: Nālandā Translation Committee, 1990), page 7; *82: The Heart of the Buddha*, page 158; *84: Journey without Goal: The Tantric Wisdom of the Buddha* (Boston: Shambhala Publications, 1981), page 23; *86:* from "Meetings with Remarkable People," in *First Thought Best Thought*, page 124; *88:* "Samsara and Nirvana," in *First Thought Best Thought*, page 19; *90:* from "Oxherding Pictures," in *Mudra*, page 90; *92:* from "Oxherding Pictures," in *Mudra*, page 90; *94: Shambhala: The Sacred Path of the Warrior* (Boston: Shambhala Publications, 1984), page 86; *96: Shambhala*, page 142; *99:* from "Song of the Golden Elephant," in *Mudra*, page 31; *100: Shambhala*, page 84; *102: 1976 Seminary Transcripts, Hinayana-Mahayana* (Boulder: Vajradhatu, 1978), page 159; *104: Shambhala*, page 63; *106: Crazy Wisdom* (Boston: Shambhala Publications, 1991), page 165; *108: Shambhala*, page 103; *112: The Heart of the Buddha*, page 97; *114: Journey without Goal*, page 37; *116: Journey without Goal*, page 114; *120:* "Garuda Is the Mighty Force," in *Warrior Songs* (Halifax, N.S.: Vajradhatu Office of Publications & Archives, 1991); *122: Shambhala*, page 58; *124: Shambhala*, page 130; *128: Shambhala*, pages 129–130; *130: Shambhala*, page 82; *132: Shambhala*, page 144; *134:* from "Auspicious Coincidence," in *Warrior Songs*; *136:* from "Haiku," in *Warrior Songs*; *138: Shambhala*, page 86; *140: Shambhala*, pages 44–45; *142:* from "The Vajradhatu Anthem," unpublished poem; *144: Shambhala*, page 177; *146: Journey without Goal*, page 140; *148: Shambhala*, page 96; *150:* from "The Nameless Child," in *First Thought Best Thought*, page 33; *152: Shambhala*, page 50; *154: Shambhala*, page 179.

Selected Chronology

Vidyadhara the Venerable Chögyam Trungpa, Rinpoche

1940	Born in Nangchen, Eastern Tibet.
1941	Enthroned as eleventh Trungpa, supreme abbot of Surmang monasteries, and governor of Surmang District.
1945–59	Studied calligraphy, thangka painting, and monastic dance in addition to traditional monastic disciplines.
1958	Received degrees of *kyorpön* (doctor of divinity) and *khenpo* (master of studies) as well as full monastic ordination.
1963–67	Spaulding sponsorship to attend Oxford University; studied comparative religion, philosophy, fine arts.
1968	Cofounded Samye Ling Meditation Centre in Dumfriesshire, Scotland.
1970	Arrived in North America.
1971–77	*Garuda, A Periodical Journal.* Editing, design and layout *Garuda* 1–5.
1972	Founded Mudra Theater Group.
	Milarepa Film Workshop, Lookout Mountain, Colorado.
1972–87	Design work: graphics and posters, banners and fabric design, furniture, book design, set and costume design, jewelry, photography.
1973	Founded Vajradhatu, an international association of Buddhist meditation and study centers.
	Mudra Theater Conference, Boulder, Colorado.
1974	Founded Nalanda Foundation, an association of educational and contemplative arts associations.
	Founded The Naropa Institute, the only accredited Buddhist-inspired university in North America.

Art in Everyday Life, Willits, California.

Thangka exhibit, the Asian Gallery of the Avery Brundage Collection, de Young Museum.

1975 *Visual Dharma: The Buddhist Art of Tibet.* Hayden Gallery, Massachusetts Institute of Technology.

1976 Director, *The Life of Milarepa,* Centre Productions, using footage from Ethnographica Museum in Stockholm, Sweden.

Visual Dharma, Willits, California. Flower arrangements, calligraphy, and poetry readings.

1977 Director, *Empowerment,* Centre Productions, a documentary of visit of His Holiness the Gyalwang Karmapa XVI to North America in 1976.

1978 Flower arranging exhibition, Emmanuel Gallery, University of Colorado, Denver.

1978–86 Dharma art seminars: a series of seminars taught at The Naropa Institute and elsewhere throughout North America on creativity and meditation.

1979 Flower arranging exhibition, University of Colorado, Denver.

Heaven, Earth and Man, a portfolio of thirteen silkscreened drawings and calligraphies, Gritz Visual Graphics, Boulder, Colorado.

1980 *Discovering Elegance: An Environmental Installation and Flower Arrangements,* Los Angeles Institute of Contemporary Art.

Flower arranging exhibition, Boulder Center for the Visual Arts.

Four Calligraphies, in conjunction with Kanjuro Shibata Sensei, Los Angeles, edition of thirty.

Kami, silkscreen calligraphy, Centre Productions, edition of fifty.

1981 Director, *Discovering Elegance,* Vajradhatu, using footage of his installation in Los Angeles, 1980.

One-man show of calligraphies, Satori Gallery, San Francisco.

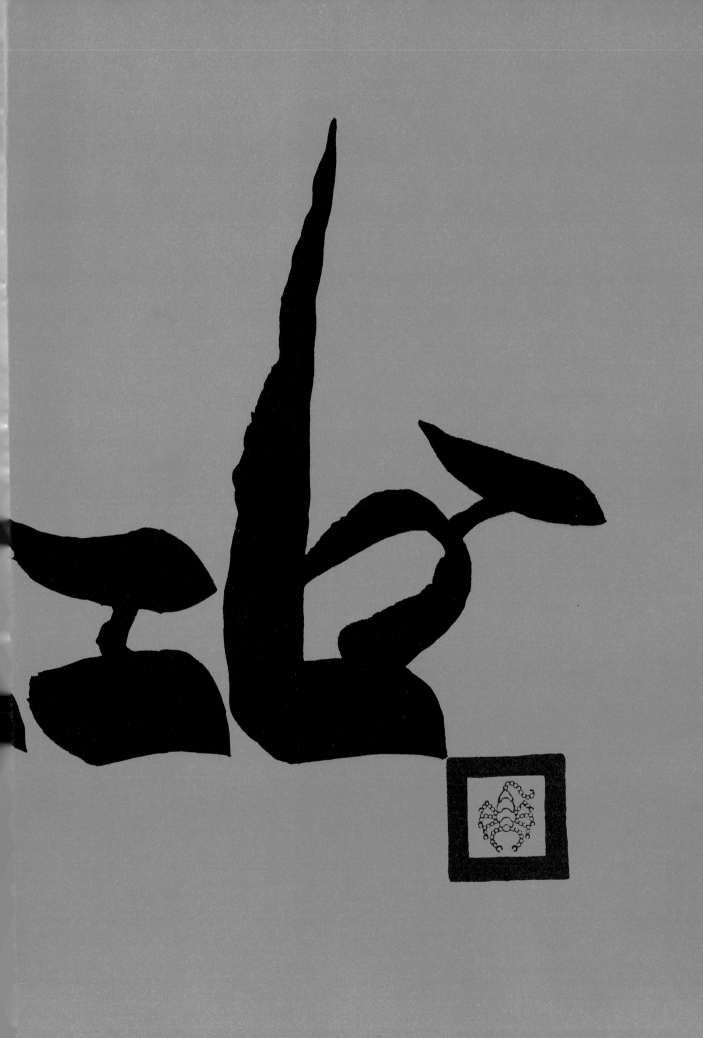

Meditation Centers and Resources

For further information regarding meditation or inquiries about a dharma center near you, please contact one of the following centers:

Karmê-Chöling
Star Route
Barnet, VT 05821
(802) 633-2384

Rocky Mountain Dharma Center
4921 County Road 68C
Red Feather Lakes, CO 80545
(303) 881-2184

Vajradhatu Europe
Zwetchenweg 23
D3550 Marburg
Germany
49 6421 34244

Vajradhatu International
1084 Tower Road
Halifax, N.S. B3H 2Y5
Canada
(902) 425-4275

Many talks and seminars are available in cassette tape format. For information, call or write:

Vajradhatu Recordings
1084 Tower Road
Halifax, N.S. B3H 2Y5
Canada
(902) 421-1550

The Vajradhatu Archives keeps a registry of the ownership of original manuscripts, tapes, and works of art by Chögyam Trungpa, so that they can be located for research and exhibit purposes. For further information, or to register an item, call or write:

Vajradhatu Archives
1084 Tower Road
Halifax, N.S. B3H 2Y5
Canada
(902) 421-2696

Winter Beauty: An Environmental Installation, Boulder Center for the Visual Arts.

1982 *Discovering Elegance: An Environmental Installation and Flower Arrangements*, Emmanuel Gallery, University of Colorado, Denver.

Founded Miksang Photographic Society, Kalapa Ikebana school of flower arranging.

1982–83 Consultant to the curators of *The Silk Route and Diamond Path: Esoteric Buddhist Art on the Trade Routes of the Trans-Himalayan Region*, Frederick S. Wight Gallery U.C.L.A. and the Smithsonian Institute.

1987 Death in Halifax, Nova Scotia; cremation at Karmê-Chöling, Barnet, Vermont.